IMAGES
*of America*

# CRANSTON
# REVISITED

IMAGES
*of America*

# CRANSTON
# REVISITED

Sandra M. Moyer and Thomas A. Worthington

ARCADIA
PUBLISHING

Published by Arcadia Publishing
Charleston, South Carolina

Printed in the United States of America

Library of Congress Control Number: 2013943019

For all general information, please contact Arcadia Publishing:
Telephone 843-853-2070
Fax 843-853-0044
E-mail sales@arcadiapublishing.com
For customer service and orders:
Toll-Free 1-888-313-2665

Visit us on the Internet at www.arcadiapublishing.com

*This book is dedicated to the members and friends of the Cranston Historical Society who, since 1949, have given tirelessly of their time and resources in preserving Cranston's past for the benefit of those, present and future, who appreciate the rich history of this city.*

# CONTENTS

# ACKNOWLEDGMENTS

The Cranston Historical Society's mission is to preserve and promote Cranston's history. Many people have entrusted to the society donations of furniture, collectables, artifacts, maps, print materials, and photographs. Much of our work today is based on the efforts of early members of the Cranston Historical Society who worked endlessly to research, publish, and preserve our city's history. Special recognition goes to Gladys Brayton, Bette Miller, and Alice Baxter for the many years of work they contributed during their lifetimes.

The authors would like to particularly thank Jim Hall, the current curator, for assisting us with locating photographs and providing information. He is building on the work of earlier curators by documenting and organizing the society's collections with computer software, thereby making it more accessible to the public.

We would also wish to offer our sincerest thanks to the many people who contributed photographs or information that made this book possible. Lending us photographs were Henry A.L. Brown, Virginia Browning, Donald Carpenter, Martha Cornell, Anne Crocker, Larry DePetrillo, John Dyer, Ernest Hutter, Gregg Mierka, Elaine Miller, the Oak Lawn Baptist Church, Jim and Margaret Pine, Don Rotteck, Linda Shaw, David Shippee, and the Worthington family. The people who provided us with information were Donna Belle Garvin, Barbara Leeman, Marie Sanda, Elsie Williams, and Lisa Zawadzki.

All photographs and images, unless otherwise noted, belong to the Cranston Historical Society. The authors' proceeds from the sale of this book will go to the Cranston Historical Society's endowment fund to support the future work of preserving and promoting our city's history as well as maintaining the Joy Homestead and the Governor Sprague Mansion.

# INTRODUCTION

Three dates stand out in Cranston's history—1638, the date it was first settled; 1754, the year it became a town; and 1910, when it was incorporated as a city. Each event involved disputes that made for an intriguing part of Cranston's story.

When Roger Williams was banished from Massachusetts Bay Colony for defying the authorities with his radical new ideas, he started the settlement of Providence in 1636 on land given to him by the Narragansett Indians. Within this community, Roger granted full "liberty of conscience," as he called it. Government would have no say in how people expressed their spiritual beliefs, and all religions would be welcome.

Two years later, Providence was embroiled in a controversy concerning a man's right to stop his wife from attending church services. Roger supported the woman's religious liberty while other residents, including William Arnold and William Harris, sided with the husband and his right to control his wife. When the majority of the town voted against the husband, he returned to a settlement in Massachusetts Bay Colony. Arnold and Harris also left Providence and, along with others, settled on the northern side of the Pawtuxet River in 1638. Roger Williams had just received this additional land from the Narragansett sachems Canonicus and Miantinomi, and he sold it to the new settlers for the price of a cow.

This settlement was named Pawtuxet and was the beginning of what is now Cranston. William Arnold built a home on 1,000 acres just north of the Pawtuxet Falls, near present-day Warwick Avenue. William Harris settled farther north in the meadows near Blackamore Pond along the Pocasset River, a tributary of the Pawtuxet River. Religion had not been the motivation for Arnold and Harris to come to Providence nor was it the sole reason for why they left to settle farther south. The two men, although not friends, were similar in their drive to obtain as much land for themselves as possible. Their greed resulted in decades of feuding with Roger Williams and the other settlements surrounding Pawtuxet such as Shawmet (now Warwick) and Meshanticut (now western Cranston). While Williams wanted to make land available for new settlers looking for religious freedom, Arnold and Harris wanted only to enlarge their own holdings. They were willing to ally themselves with the enemies of Rhode Island to accomplish this.

William Arnold went so far as to try to claim much of Providence for himself by physically altering Roger Williams's original deed. When that failed, he asked Massachusetts to take over the Pawtuxet settlement and the surrounding land in the hope that gaining the favor of Williams's enemies would give Arnold more land. As a result, Pawtuxet remained separate from the rest of the colony for 16 years. Likewise, William Harris fought to extend the Pawtuxet boundaries all the way to Connecticut so he could claim many acres of new land. He, too, was willing to jeopardize Rhode Island's existence by encouraging Connecticut to take its land.

Despite these disputes that kept the boundaries of the new settlement undefined for many years, other people settled in the area, both in the area around the Pawtuxet River and in

the newer Meshanticut Purchase that comprised what is now western Cranston. Their names frequently live on as the names of streets, hills, or streams. William Carpenter and Zachariah Rhodes settled along the Pawtuxet River near Pawtuxet. The descendants of William Harris lived in present-day Woodridge and Garden City; while Jacob Clarke, who started out as an apprentice to Harris, was later given land by him near what is now the intersection of Budlong Road and Park Avenue. The Westcott family had a farm between what is now Sockanosset and Knightsville. Nicholas Sheldon had 3,000 acres in the north central part of the settlement, while the Knights lived in the northwestern section.

Arthur Fenner built a garrison house in 1655 for protection against the Indians in what is now Thorton. When that house was burned in an Indian uprising, Arthur built another home for himself as well as a nearby house for his son Thomas. The Maj. Thomas Fenner house is now Cranston's oldest building. The Potter family lived in the south central area near Meshanticut Brook. Early settlers of the area around what is now Phenix Avenue were John Herrod, Roger Burlingame, and Thomas Ralph. Ralph's son-in-law Edward Searle settled in what became the Oak Lawn section and, in 1677, built a house on Wilbur Avenue, which survives to this day. The Randall, Dyer, and Sprague families lived where Knightsville is now located. A few years later, the Stone family had a farm near present-day Pontiac Avenue.

After 1658, when the settlers of Pawtuxet finally decided to rejoin Providence, the two communities became one. But by the mid-1700s, the citizens of the area that was to become Cranston were tired of having to travel long distances to the center of Providence in order to conduct government business. The four villages of Pawtuxet, Mashpaug (near what is now Auburn), Knightsville, and Searles' Corner (later renamed Oak Lawn) had long been united in their desire to separate from Providence and form a separate town. What they could not agree on was the name for the new town. The four Indian names of Pawtuxet, Mashapaug, Mashantatuck, and Pocasset were suggested, but no consensus was reached.

After decades of debate, the citizens finally agreed on Lynn since many of them had come from a town in Massachusetts with the same name. But when Rhode Island's general assembly approved the petition to create a new town in 1754, the name Lynn had been crossed out and Cranston was written in its place. To this day, historians still disagree as to whether the town was named after Samuel Cranston, a former governor long dead by this time, or Thomas Cranston, who was speaker of the House when the incorporation bill was voted upon. However, the inscription on the opening page of the first town record book indicates that it was a gift from Thomas Cranston, which perhaps lends credence to him being the more likely honoree.

Charged with running their own affairs in a democratic manner, the citizens of the new municipality held often contentious town meetings. Conflicts were settled, taxes were levied, and plans were made for the maintenance of the roads as well as caring for the poor. The time around the American Revolution was especially difficult. As Rhode Island demanded more funds and soldiers to support the war effort, Cranston incurred large debts in providing for the state's defense and in granting financial incentives for the town's men and slaves to enlist. Cranston and its citizens contributed in other ways. Some of the iron that went into making cannons and cannonballs came from ore beds in Oak Lawn. The water off the coastline of Pawtuxet was the site, in 1772, of the burning of the British ship HMS *Gaspee* and the shooting of its captain, Lieutenant Dudingston. This event is still commemorated each June as the first incident of bloodshed against England.

By the time of the American Revolution, the population of Cranston had grown slowly but steadily. Then, around the end of the 18th century, many young residents moved west to take advantage of better farmland in New York and Pennsylvania. As a result, the 1800 Census shows a decrease in population. This trend was reversed a few decades later when industrialization brought a wave of European immigrants to work in the textile mills owned by the Spragues and others. But in the 1860s, the population again declined when Providence annexed a large portion of northeastern Cranston including what are now South Providence, Elmwood, and Washington Park. Residents of those areas were more likely to be Republicans, and they feared the loss of

political dominance if they remained tied to the immigrants, usually Democrats, who had come to work on the farms and mills in the rest of the town.

The mid-1860s also brought the Civil War. Again, Cranston did its part to support the war effort. After the battle at Fort Sumter, Gov. William Sprague of Cranston immediately answered President Lincoln's call for volunteers by organizing and outfitting two infantry regiments and an artillery battery. For his bravery in the first Battle of Bull Run, he was commissioned a brigadier general. The town itself also incurred great expense by offering any man who enlisted a monthly bounty of $25 as well as giving a stipend to his family.

Improvements in transportation were responsible for the next big increase in Cranston's population. First, there were railroads and horse-drawn streetcars and then, starting in the 1890s, electric trolley lines connecting Providence with Cranston, which made it possible for people who worked in the capital to live in the growing suburbs of its neighboring town. Areas in eastern Cranston such as Auburn, Eden Park, and Edgewood grew rapidly and even the western villages of Meshanticut, Knightsville, and Oak Lawn benefitted from easy access to Providence and beyond.

By 1910, Cranston's population had grown to over 21,000. Although it was still mostly farms, there was also significant manufacturing and commerce. For over 15 years, there had been talk of becoming a city. Some citizens, especially real estate developers like James Budlong and John Dean, hoped that this proposed change would increase municipal services and attract more people. Other residents did not want to change the rural character of Cranston. They worried that a city form of government would decrease voters' control of finances by eliminating the town meeting and thus increase taxes.

When the pro-development Republicans proposed becoming a city, Cranston voters twice rejected the idea. Refusing to be deterred, the Republicans on March 10, 1910, persuaded the Rhode Island General Assembly to make Cranston a city without its citizens' approval. The voters quickly retaliated by electing as mayor, Democrat Edward Sullivan, who had been an outspoken critic of becoming a city. They also chose Democrats for the majority of city council seats.

In the years since its incorporation as a city, Cranston has continued to grow. Two events, in particular, have caused rapid growth in the 20th century. After World War II, returning servicemen bought homes in new subdivisions, such as Garden City and Dean Estates. Schools, churches, and businesses soon followed. Then in the 1980s, the rezoning and reappraisal of farmland caused the taxes to become so burdensome that many family farms in the western part of Cranston were sold to developers. This led to more residential construction, which continues to this day.

Now, small villages, once separated by farmland, have been linked together by suburban housing subdivisions. New shopping areas and industrial parks have flourished. But some things have remained the same. The two political parties still spar as they take turns dominating the mayor's office and the city council. Tax revolts by the citizens erupt periodically as finding a balance between the demands for more services but lower taxes remains difficult. People still fight new residential developments that will change their neighborhoods. A dispute over liberty of conscience made the national news 374 years after the problem that engulfed Providence. In 2012, one of the city's high schools was forced by the courts to remove a 50-year-old prayer banner from the auditorium wall when an atheist student complained that it violated the separation of church and state. Not surprisingly, Roger Williams's name was frequently invoked in the ensuing controversy.

Cranston has weathered disputes since its founding and throughout its history as a settlement, a town, and a city. Somehow, it has managed to overcome these difficulties and prosper. Perhaps knowing Cranston's history will help us to understand that the issues have not changed very much over the years. Human nature remains the same, and people, looking out for their own best interests, will have honest disagreements with their neighbors who have different ideas and priorities. But the story of Cranston is also built on its citizens' initiative, perseverance, and hard work. Those are the attributes that this book strives to celebrate as it examines, through vintage photographs, the everyday life of Cranston residents during the last 350 years.

Sadly, every year more of Cranston's old buildings are lost to accidental fires and intentional progress. As more previously open land is developed into housing subdivisions, the sense of place and the mental images of how things formerly looked are lost. Hopefully, the city's citizens will assist the Cranston Historical Society in continuing the work of this book in preserving Cranston's history by keeping the stories and photographs alive.

# One

# AGRICULTURE

The settling of what is now Cranston occurred because of a desire for more farmland. The meadows along the Pawtuxet River proved to be fertile land for the first families to settle there. Gradually, other farms were created west and north of the original settlement. At first, these farms provided food for the owners' families with perhaps a little left over to sell.

Over time, some of the Cranston farms became commercial successes. By 1910, the value of Cranston's farmland was third-highest in the state. Although most farms raised a variety of crops and animals, certain areas became associated with specialized products. The eastern part of Cranston, because of its nearness to a ready market in Providence, became known for vegetables. The Budlong farm in Auburn was noted for growing tomatoes, asparagus, onions, horseradish, and cucumbers. The family also made ketchup and pickles, giving the area the nickname Pickleville. They later grew roses in huge greenhouses near Rolfe Street.

In the center of Cranston on both sides of what is now Oak Lawn Avenue, first Henry King in 1793 and then, over a century later, John Dean had extensive apple orchards. The streets in this area are now named for some of the varieties of apples he grew, such as Greening and Baldwin. Besides his nearly 6,000 apple trees, Dean also cultivated raspberries, strawberries, blackberries, and peaches.

Farther west, the hilly land was more suitable for dairy farms. By 1910, it was said that half the state's milk came from Cranston. Important names in dairy farming included Brown, Cornell, and Burlingame.

With the growing popularity of farmers' markets and the trend toward eating locally produced food, Cranston farms are having a resurgence. Stamp, Confreda, and Pippin are just a few of the names associated with present-day farming.

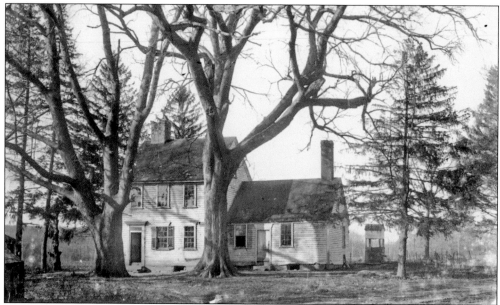

The Harris family was the earliest to settle in what would become central Cranston. William Harris left Providence in 1638 and settled near Blackamore Pond. He and his descendants came to control vast tracts of meadowlands along the Pocasset River, and their homestead is seen in the photograph above. North Farm, near the present-day intersection of Park Avenue and Budlong Road, was given to Harris's former indentured servant Jacob Clarke. By 1715, grandson Andrew Harris owned Middle Farm, seen in the photograph below, which was located where Woodridge is today. In 1733, Joseph Harris owned South Farm, the location of today's Garden City, and James Harris lived near Pontiac Avenue in a house built in 1708. This land was still owned by the Harris family in the late 1800s when a coal mine operated on the site of Newport Creamery in Garden City, but in 1897, the Budlong family purchased most of the acreage.

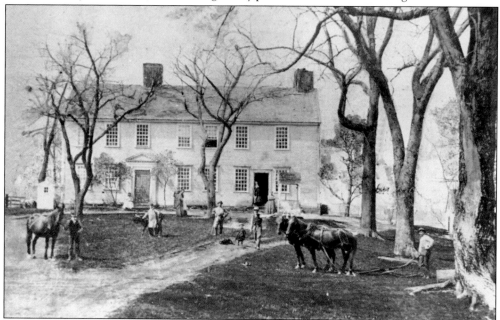

Farming was a family enterprise, and everyone was expected to work. Besides taking care of the children and performing all the household duties, a farmwife often tended the family's kitchen garden and milked the cows. During planting and harvesting time, she would join her husband in the fields. In the photograph below, a woman is shown using a horse-pulled hay rake on the Turner farm in Oak Lawn. Francis Turner purchased the farm in 1849 from the Searles, the family who first settled the area in 1671. The village was originally called Searle's Corner, but Job Wilbur changed its name to Oak Lawn in the 1870s when he and Francis Turner platted their land for development. (Below, courtesy of David Shippee.)

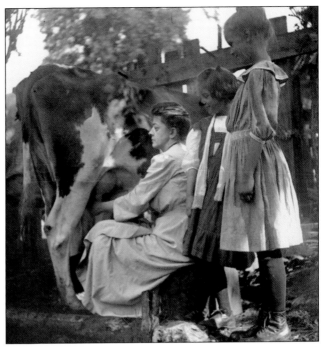

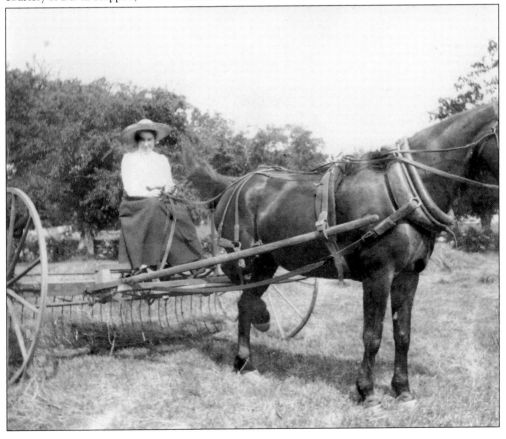

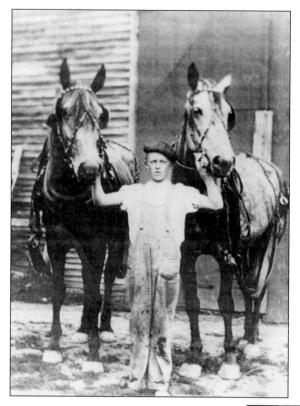

Even a young child could perform simple tasks like feeding the animals or carrying in wood. By the time they were teenagers, the boys were doing the work of a man. This c. 1910 photograph shows Everett Cornell (Sr.) with two of the Cornell family's farm horses. (Courtesy of Martha Cornell.)

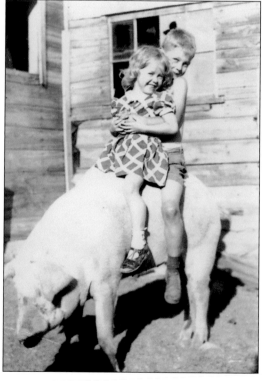

Although farming was a lot of hard work, even for the children, that did not mean that the youngsters did not have any fun. In this 1948 photograph, Linda and Lowell Cornell ride one of the larger pigs on the family farm located on Phenix Avenue. (Courtesy of Martha Cornell.)

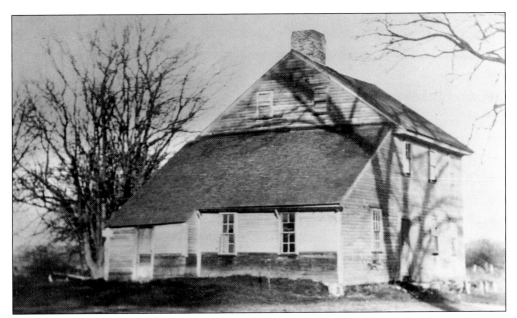

This house, once located near Natick Road, was part of the Rivulet Farm, owned in the mid-1700s by John Potter, a Quaker minister. When his grandson, Israel Potter, was not allowed to marry a neighbor's daughter, the young man left home and began a series of adventures including fighting at Bunker Hill, being kidnapped at sea by the British navy, and serving as a spy for Benjamin Franklin in Paris. After Israel returned as an old man, he published an account of his adventures that was later used by Herman Melville as the basis of his book titled *Israel Potter: His Fifty Years of Exile*. In the photograph at right, Marian Greene poses in front of the same farm, which was later platted for housing behind the Oak Lawn Library. (Right, courtesy of Linda Shaw.)

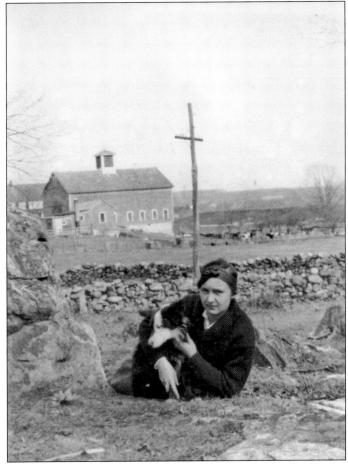

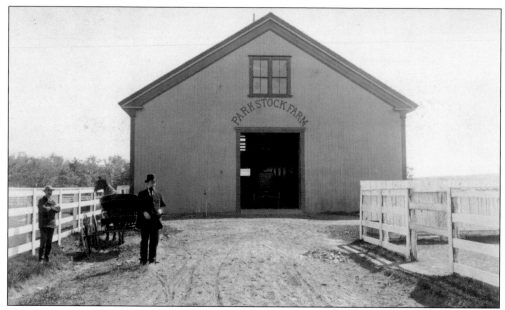

The Park Stock farm was located in the area of current-day Park Avenue. Jonathan Comstock, who raised racehorses for the nearby Narragansett Trotting Park, located where the Cranston Stadium is today, owned it. The Narragansett Trotting Park was started by Amasa Sprague in 1867 and attracted fans from around the Northeast.

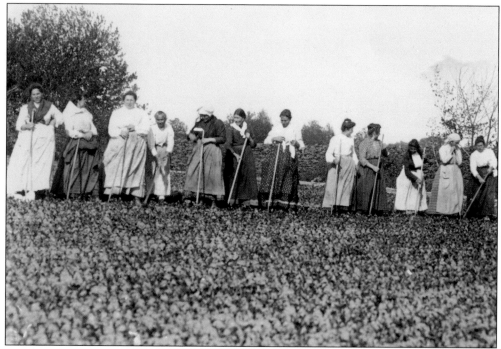

The Patt farm was in Auburn, conveniently close to the Providence market. In this c. 1910 photograph, some women work in the vegetable fields. Because of the cheap labor provided by immigrants, it was more cost-efficient to use large numbers of farmhands than it was to buy farm machinery. (Photograph by Wilfred Stone.)

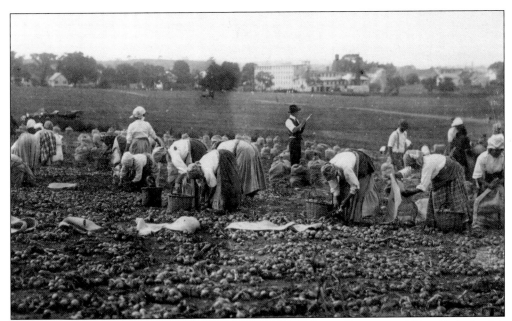

The Budlong farm in Eden Park sold vegetables to Providence, Boston, and New York. In this c. 1900 photograph, two men supervise the backbreaking work of women harvesting onions. Immigrants from several European countries, particularly Sweden and later Italy, worked on the farm. The Budlongs, who owned one of the largest farming enterprises in New England, were also famous for their pickles, vinegar, ketchup, and roses.

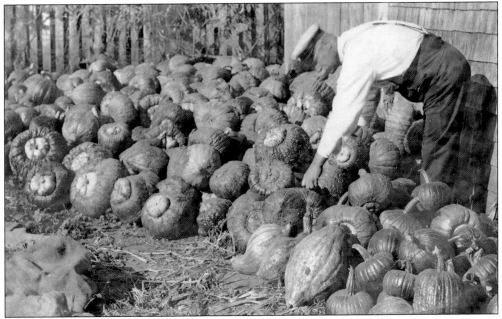

Harvesttime in the fall created some intriguing opportunities for photographers, as with this portrait of a farmer with his pumpkin crop. Wilfred Stone produced an entire collection of remarkable photographs of Cranston farms in the early years of the 20th century. He helped to document a way of life that would sadly disappear before too many years had passed. (Photograph by Wilfred Stone.)

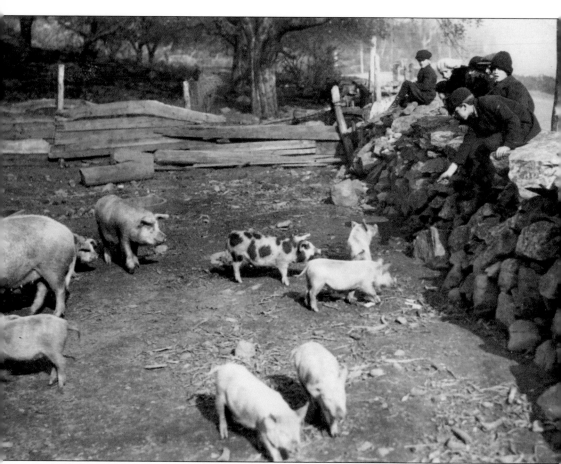

Besides growing crops of various types of vegetables, Cranston farms also raised animals such as horses, cattle, sheep, goats, chickens, and pigs. On this farm near Furnace Hill on Phenix Avenue, Sam Brayton, Harry Burlingame, Del Bonis, and their friends admire the pigs that would eventually provide the farmer that owns them with ham, bacon, pork, leather, and bristles that could be used in the making of brushes. Since these animals are omnivores and will eat almost anything, they appreciate whatever the boy to the extreme right feeds them. (Photograph by Wilfred Stone.)

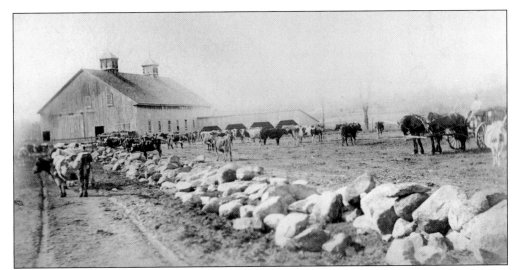

Dairy farming was popular in the western portion of Cranston for over 200 years. This farm on Hope Road, with its large unpainted barn and horse-drawn wagon, was typical of the 19th-century family farm. The rocks that were removed from the fields were loosely piled along the boundaries of the fields.

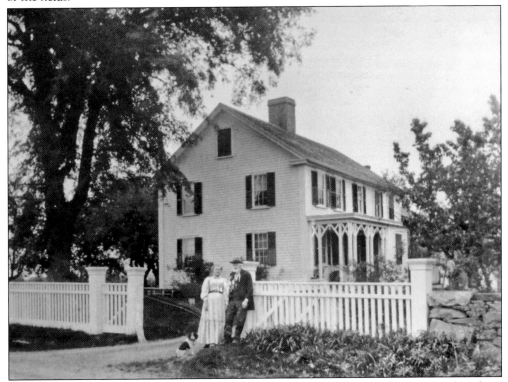

Mason Cornell and his granddaughter-in-law Mabel are shown in this c. 1890 photograph in front of their farmhouse. In the 1960s, this Phenix Avenue farm became the site of Cranston High School West and Western Hills Middle School. The farmhouse was where the tennis courts are today, and the nearby 1879 family mausoleum is all that remains of the family farm. (Courtesy of Martha Cornell.)

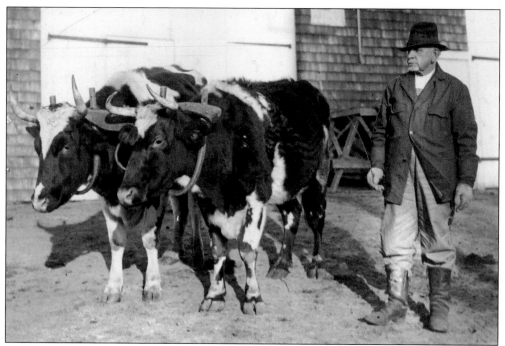

In the photograph above, Fred Andrews is shown with his team of oxen, an important possession in the days before small farmers could afford tractors to pull farm machinery. In 1938, he sold this western Cranston farm on Burlington Road, seen in the photograph below, to the Cornell family, who added the acreage to their holdings on Phenix Avenue. Everett Cornell Jr. ran it for many years until the late 1960s, when it was sold to the Lombardi family, who made it the site of the golf course at the Cranston Country Club. (Below, courtesy of Martha Cornell.)

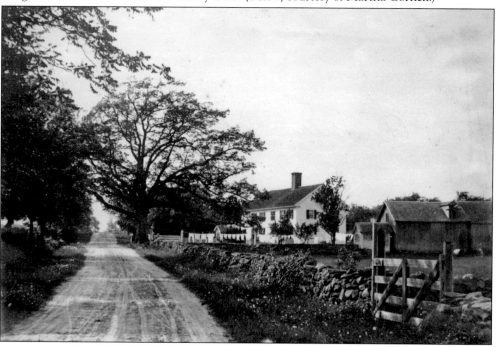

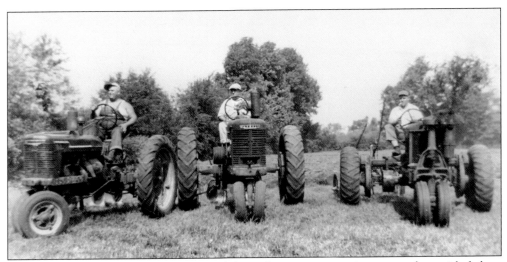

For many years, family farms were passed down from one generation to another, with fathers teaching their sons the necessary agricultural skills as well as instilling in them a love of the land. In the photograph above, Everett Cornell Sr. (middle) and his sons, Lowell (left) and Everett Jr., work together on the Cornell farm on Burlingame Road. However, when the picturesque dairy farms of western Cranston became less profitable in the mid-20th century, many members of the younger generation of the longtime farm families were forced to sell their land to make way for housing developments, schools, or country clubs. (Above, courtesy of Martha Cornell.)

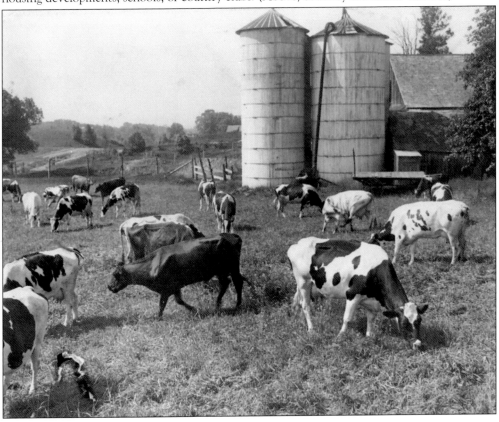

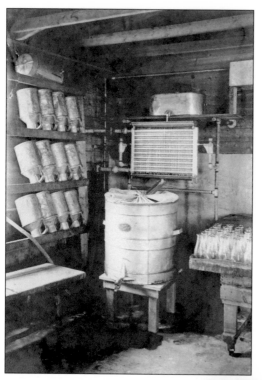

Besides raising and milking their cows, some of the dairy farmers of western Cranston processed and marketed their own milk and other products. The photograph at left of the Hervey farm's milk room shows the machinery used to pasteurize the milk as well as the metal containers and glass bottles in which it was sold. The Cornell Diary Farm also marketed its own milk products and eggs, as seen in this advertising display in the photograph below. Customers could have fresh dairy products delivered regularly to their homes without having to go to a store. Farm stands were another way for farmers to sell directly to the consumer. (Below, courtesy of Martha Cornell.)

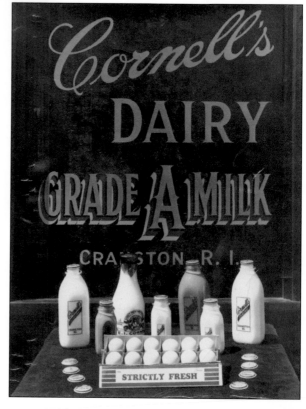

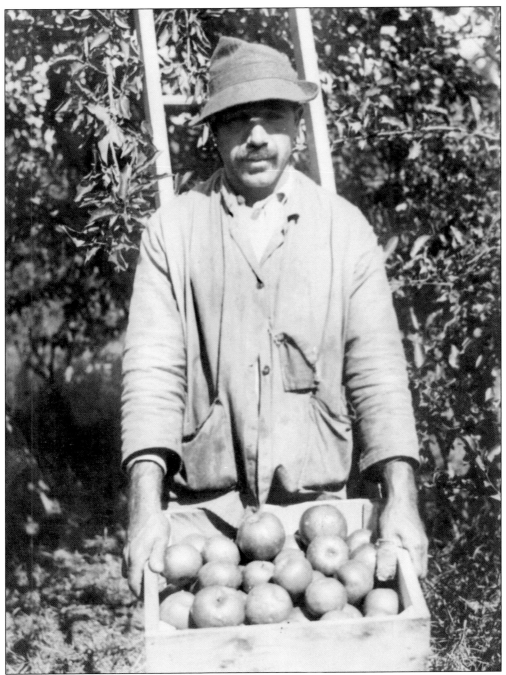

Orchards were popular in the central and western parts of the city. Sockanosset Hill was home to the King fruit orchards starting in 1793. About 100 years later, John M. Dean purchased the land from the King family and planted fruit-producing trees and bushes. Dean employed up to 70 workers at a time and earned $20,000 a year from selling his farm produce. In the photograph, a worker is seen holding some Dean apples. Dean dreamed of developing this farm as a model community, but he died in 1938 before fulfilling it. That was the same year a hurricane destroyed his 6,000 apple trees. Later, his grandson developed Dean Estates as a residential community.

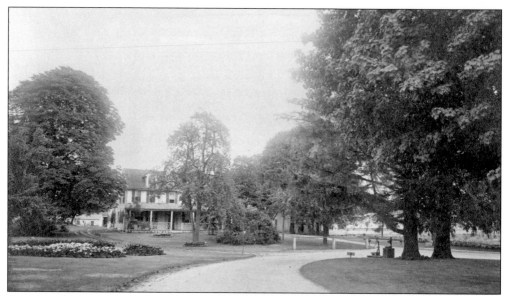

An unusual crop was raised on the Dyer family's Pocasset River estate. Charles and Daniel Dyer had planted 20,000 ornamental and fruit trees on the 40-acre Dyer's Nursery. Around 1828, they changed the name to Mulberry Grove and began growing mulberry trees to feed silkworms for fabric production. Within 10 years, cold weather and a fungus ended the enterprise.

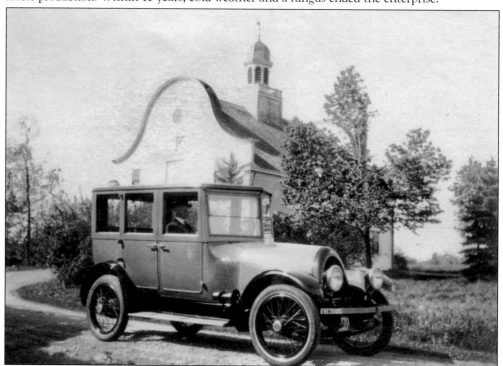

The northwestern part of Cranston was the location of the Comstock Farm on Apple House Hill. This barn and the nearby house sported an unusual curved roofline, which was similar to a building that the Comstocks saw at the 1904 St. Louis Exposition. The home stood for about 50 years before it burned. Later, the farm was platted for houses.

# *Two*

# MANUFACTURING

Archaeological evidence reveals that mining in the area that is now western Cranston existed almost 4,000 years ago. Indians made bowls, pipes, and tools from the soapstone they found in two quarries in the Oak Lawn area. Years later, a nearby iron ore bed on Meshanticut Brook provided the metal to make canons for the American Revolution. Starting in the early 1800s, granite from Fenner's Ledge in Arlington provided building materials. The Harris family and later the Budlongs owned a coal and graphite mine in what is now Garden City.

Although farming was the main way for the early settlers to make a living, manufacturing became just as important in some areas. Moving water powered gristmills and sawmills that produced flour and lumber for the emerging settlement. In the 1600s, Pawtuxet had a distillery near Stillhouse Cove. In the west, John Herrod built a mill near Furnace Hill Brook in 1662. Over the years, this mill was home to several different manufacturing concerns, including the Glennore Company established in 1839 by George Richardson to make pewter objects, including teapots.

A section of Cranston known as Joy Town, near Scituate Avenue, used waterpower to produce lumber, flour, yarn, cloth, felt hats, cider, and an alcoholic drink called Vigorine. The Joy Homestead, the foundation of the mill, and a few period homes are all that remain of this early industrial center.

Perhaps Cranston's best-known products were A&W Sprague Print Works' textiles and Narragansett Brewery's beer. Starting around 1808, three generations of Spragues produced cloth, and eventually, the printworks became the world's biggest calico printing company. The Narragansett Brewery started in 1890 in the Arlington section and became the largest lager beer producer in New England. In the 1900s, Cranston was the home of several other large companies, like the Universal Winding Company, Grinnell Corporation, and Kenney Manufacturing.

The ore beds located next to Meshanticut Brook were opened in 1767 by a group of Providence investors including the Brown family. The iron ore was used in a foundry in Hope, Scituate, and was made into canons and balls that were used during the Revolution. In 1780, an engine employed to pump water from the ore beds was the first use of steam power in the state. Mining continued until 1855.

The Arlington section did not have good soil for farming, but it did have a valuable natural resource in its rock ledge. Beginning in 1820, a quarry provided the stone for many Cranston and Providence streets as well as buildings and gravestones. In the late 1800s, graphite was also mined. The resulting tunnels presented problems when the Gladstone Street School was built over the abandoned mines in 1953.

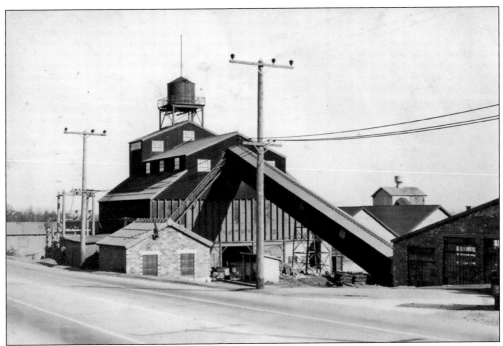

Joseph Harris, descendant of early settler William Harris, owned large tracts of land in what is now Garden City and Woodridge. Starting in 1869, the Harris Farm and Mine Company and various other companies extracted coal and graphite. Eventually, the coal mine was taken down in the 1950s for the expansion of the Garden City shopping center. (Courtesy of Larry DePetrillo.)

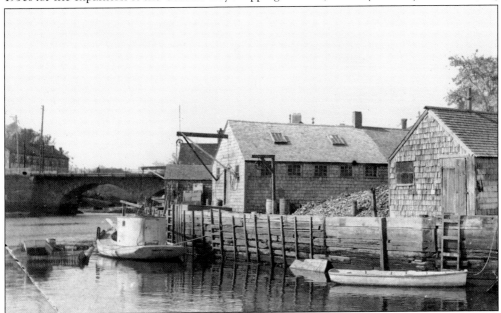

Although Cranston's shoreline is limited, many of the early settlers depended on the ocean for their livelihoods. In this Pawtuxet scene, fishing boats and sea shanties provided work for many of the residents. Oysters were an important catch for Pawtuxet Neck resident Robert Pettis, who controlled large beds in the bay and owned an oyster restaurant. (Courtesy of Henry Brown.)

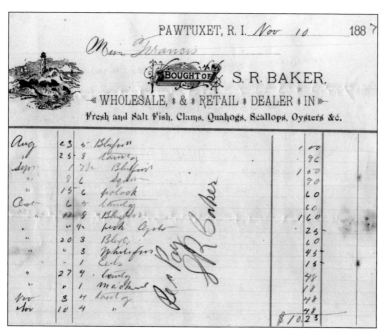

Once the fishing boats came ashore laden with the catch of the day, the fish and shellfish were quickly brought to nearby businesses in Pawtuxet. S. R. Baker was one of those establishments that sold both to wholesale and retail markets. According to this bill, Miss Francis got quite a bit of fish between August and October 1887 for only $10.20.

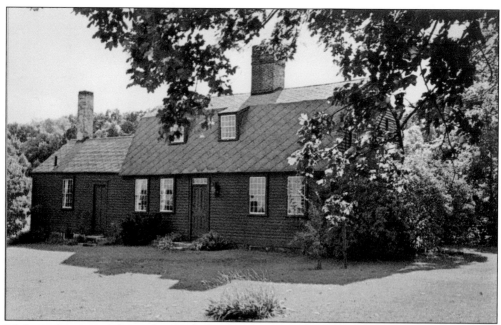

Job Joy, a farmer and shoemaker, built this farmhouse around 1770. He was not very prosperous and at one point was excused from paying taxes due to his "low circumstances." His son, Samuel, expanded the farm and was a currier and tanner as well as a shoemaker. The area around his homestead was known as Joy Town, and other artisans became part of this early industrial center. The Joy Homestead is now owned by the Cranston Historical Society.

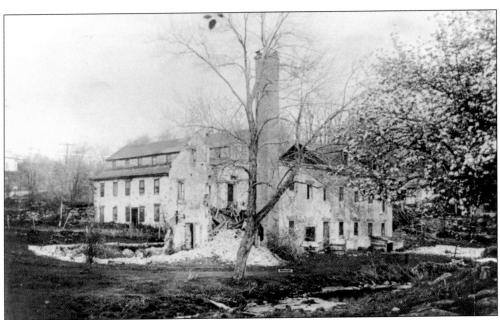

Samuel Joy also owned Dugaway Mill across Scituate Avenue from his homestead. For over 75 years and with many different owners and names, the stone mill produced flour, lumber, cloth, felt hats, pickles, and cider. Around the Civil War, the mill flourished under the name Rhode Island Print Works, but fires and competition resulted in its decline as a textile company. In the early 1900s, Charles Halstead started a company that produced Vigorine, which was advertised as a temperance drink although it actually contained 15 percent alcohol. These two photographs demonstrate how the mill deteriorated over the years before being demolished around 1950. Then, the Boy Scouts took over the area as the Champlin Reservation.

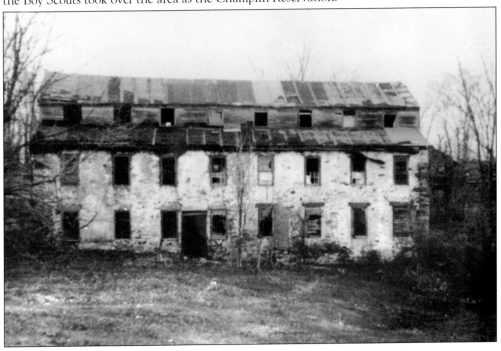

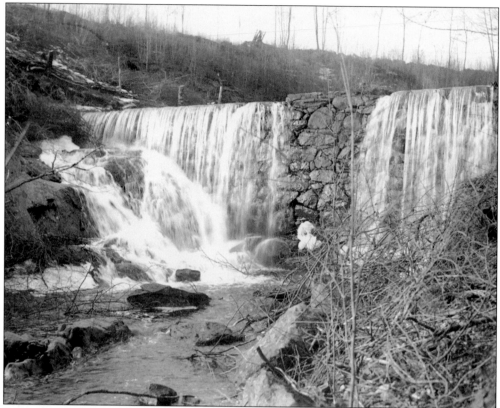

The early settlers knew the value of fast-moving water for powering mills. The photograph above is of the falls in Oak Lawn that were part of the brook, which has variously borne the name Herrod, Meshanticut, and Furnace Hill during its history. This was the site of a structure built by John Herrod around 1662 for dyeing cloth as well as for a furnace and smithery. Over the years, subsequent owners added to the mill and made stoves, braid, and Britannia ware. Around 1839, George Richardson started a pewter business called the Glennore Company. As the 19th century progressed, the mill was renamed the Cranston Furnace and then the Cranston Foundry. By 1890, the structure was in total disrepair, but the remains of a few walls have survived. (Above, photograph by Wilfred Stone.)

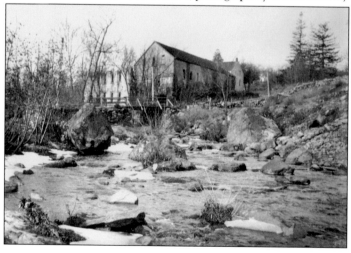

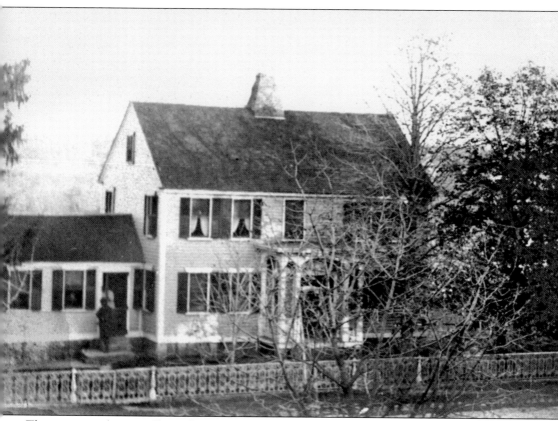

This two-story house still stands at 1040 Phenix Avenue near the Furnace Hill Brook mill. It was the home of two men, father and son, named Lodowick Brayton, who figured prominently in Oak Lawn history. Lodowick II at one time owned the Furnace Hill Brook mill, during which time it was called the Brayton foundry, but he moved his business to the Pawtuxet River when transporting materials and products by horse and wagon became too expensive. Lodowick was the president of two companies. He was a devout Baptist and funded the purchase of the Quaker meetinghouse for the Oak Lawn Baptist Church.

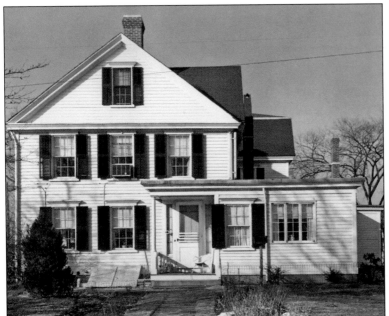

This 1790 farmhouse was the beginning of what is now known as the Sprague Mansion. It was the residence of four generations of Spragues; the family started the textile company that became one of the largest in the country. William Sprague, who farmed and operated a sawmill and a gristmill on the nearby Pocasset River, built the house.

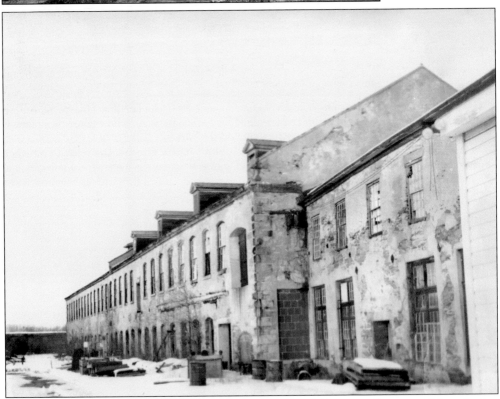

Around 1808, his son, also named William Sprague, converted the gristmill into a mill for spinning cotton thread, which was then outsourced to neighborhood women to weave into cloth. The original building burned in 1813, and Sprague rebuilt the mill with stone and improved machinery. Over the years, the family continued to add to the textile manufacturing complex.

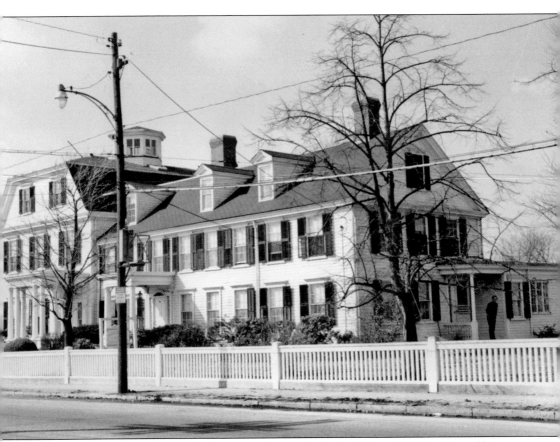

The Sprague family's home continued to grow along with the family's wealth. The first addition, around 1808, was built to face Cranston Street and added the middle doorway in this photograph. The largest addition was completed in 1864 and was entered by the grander entrance to the left. A large mahogany-paneled ballroom with chandeliers and an Italian marble fireplace dominated this first floor. The second and third floors of the addition contained four bedrooms, two adjoining dressing rooms, and two bathrooms. This addition was used to entertain the Sprague family's acquaintances from the political, financial, and sporting circles that they frequented.

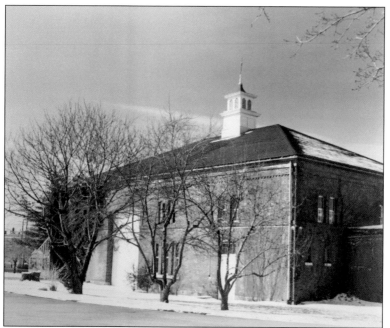

As the Sprague family's wealth increased and the second Amasa Sprague's interest in breeding and racing horses developed, a brick carriage house was erected in 1864 on the same property as the Sprague Mansion; its large doors opened onto Dyer Avenue. The horse stalls were paneled in wood. Later, a squash court was built upstairs.

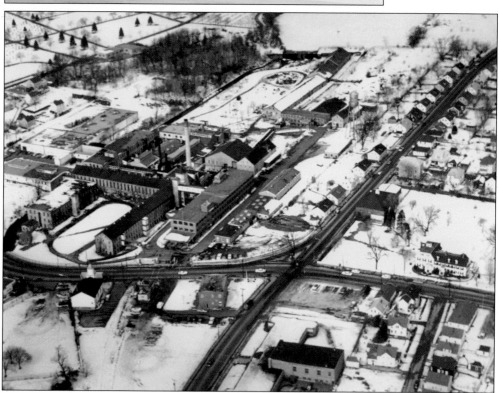

In the years that followed, the sons and grandsons of William Sprague greatly expanded the family business. A self-contained community, known as Spragueville, grew up around the mill. Workers were provided housing as well as a store, church, school, and access to a streetcar line. The Spragues also had a fire station and a railroad depot near the mill.

In the paternalistic manner popular with mill owners at the time, the Sprague family provided homes for their workers. Duplex mill houses were built across from the mansion in the 1840s and farther south on Dyer Avenue in the 1860s. Each four families shared an outhouse and a well. Central heat and indoor plumbing became available in 1931.

Near the intersection of what is now Cranston Street and Gansett Avenue, the Spragues built several larger houses for their company's supervisors. Since many of these management employees were from England, the area was called Bull Town (after the character John Bull, the Uncle Sam of England). This building, later converted into a residence, was the school for the workers' children.

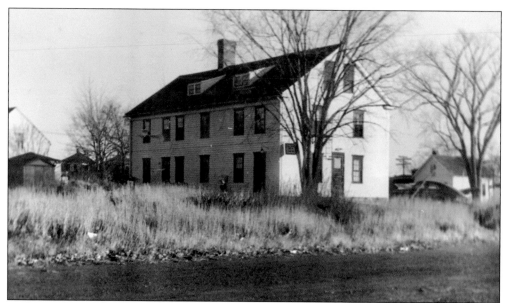

A boardinghouse for unmarried workers in the Sprague textile mills was erected in the 1860s farther west on Cranston Street, where St. Ann's School is today. The inhabitants of the 99 tiny rooms had to follow a set of rules that gave them a 10:00 p.m. curfew and strict prohibitions against gambling or drinking. They were also told to stay out of the kitchen and be prompt for meals.

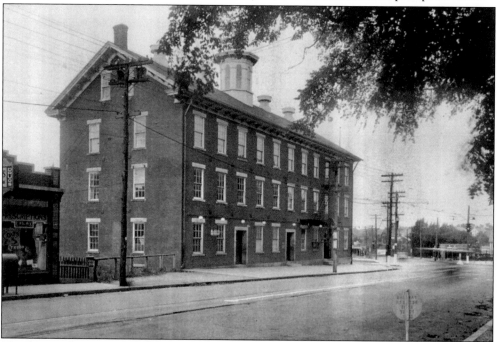

The Spragues owned the Brick Store that was built in 1858 across from the Sprague Mansion. The mill workers were paid $20 monthly and many often found that their entire pay went to settle their bill at the store. Sprague farms provided the food that was sold. Town meetings were sometimes held there, and later, the building was used for a library and a YMCA before its demolition in 1962.

This church was built in 1825 with contributions from local residents on land donated by the Spragues next to their printworks. In 1864, the building was moved across Dyer Avenue to allow for the expansion of the mill. At first, the congregation was Methodist, but later the structure became an Episcopal church and was named St. Bartholomew.

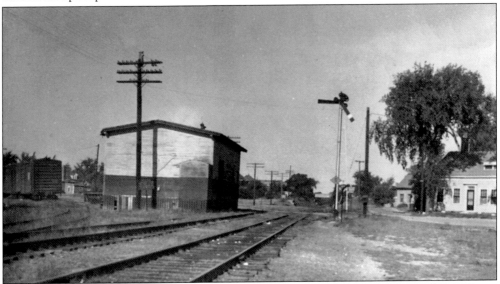

The Spragues also owned banks, trolley lines, and railroads. They built their Hartford, Providence & Fishkill Railroad to run directly to their mill so that the supplies they needed and the finished products that they made could be easily transported. The building to the left is their Haven Switch Railroad Freight House.

By 1872, the Spragues had nine mills weaving 800,000 yards of cloth and printing 1,400,000 yards of calico each week. This label would be attached to the cloth when it was sold and include the yardage. Sprague's profit for the year was $20,000,000. Unfortunately, A&W Sprague Company ran into trouble in the Panic of 1873 and went bankrupt. The company, under new owners that included the Knight family, was renamed the Cranston Print Works. In this 1880 photograph, the workers are located in the printing room where the calico textiles were made.

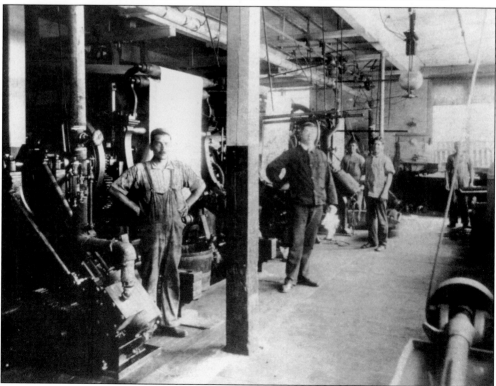

Margaret Riess (left) and Margaret Platt are seen in White Village, the name given to the 78 white mill houses off Dyer Avenue. After being owned by the printworks for over 80 years, these houses were auctioned off in 1940, about the time of this photograph. The current occupants were given priority if they could meet the highest bid, and finally, municipal services were provided. (Courtesy of Jim and Margaret Pine.)

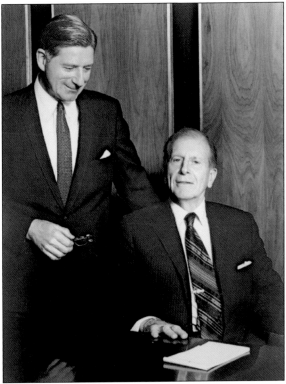

Eventually, the Rockefeller family became involved in the ownership and management of the Cranston Print Works. Pictured in the firm's executive headquarters on Dyer Avenue are Frederick Rockefeller (standing), president, and Godfrey Rockefeller, chairman of the board. In 1966, the decision was made to no longer have the factory's general manager live in the Sprague Mansion, and it was sold to the Cranston Historical Society.

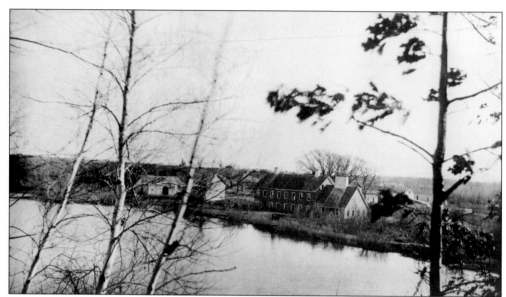

Another important industrial area in Cranston was located between the Pawtuxet River and Park Avenue. Nearest the river was the Bellefonte Manufacturing Company, which started operations in 1810 and made woolen and cotton goods, including America's first broadcloth. In 1871, it was taken over by the Turkey Red Company, which was the first to make this type of cloth. Just north of this company, near Fenner Pond, was the Elmville Mill, seen in the photograph above. Although fire destroyed the mill in 1876, some of the duplex houses built for the workers, pictured below, survived until the 1950s, when they were demolished to make room for Park View Junior High School.

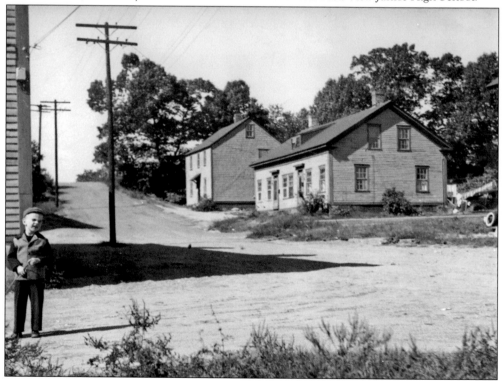

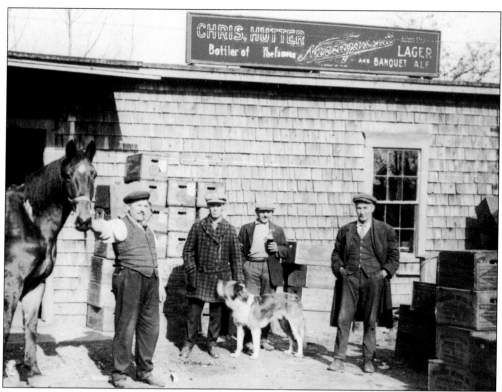

Another large Cranston business was the Narragansett Brewery, which opened in 1890 with $150,000 of capital. The property included a barn, stable, blacksmith, and an icehouse. At first, horse and wagon delivered the beer, and some of the bottling was done by other businesses, such as this one owned by Chris Hutter and seen in the photograph above. Eventually, trucks and refrigerated train cars transported the beer. By 1914, when the company built a large modern bottling plant, pictured below, it was the best-selling beer in New England, and its slogan was "Hi Neighbor, have a 'Gansett!" The brewery closed in 1981. A shopping area now occupies the site in Arlington. (Above, courtesy of Ernest Hutter.)

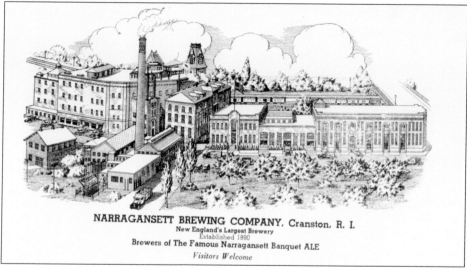

NARRAGANSETT BREWING COMPANY, Cranston, R. I.
New England's Largest Brewery
Established 1890
Brewers of The Famous Narragansett Banquet ALE
*Visitors Welcome*

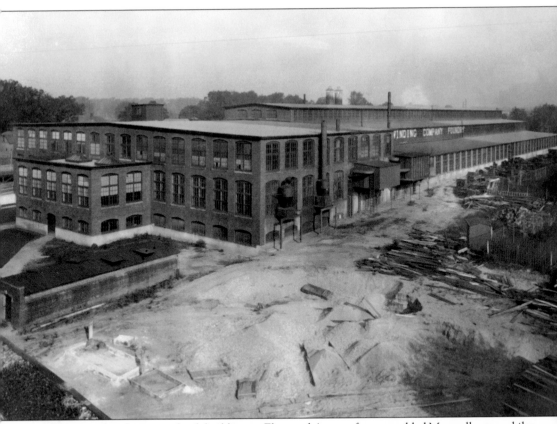

Workers in this three-story brick building on Elmwood Avenue first assembled Maxwell automobiles. Drivers, who were paid $10 a week, tested the automobiles by riding them up and down Elmwood Avenue. In 1914, the Universal Winding Company took the factory over and manufactured winding machines for the textile and electrical coil industries. At its peak, the company employed 1,500 workers and was the largest company in the world that exclusively made winding machinery. During both World Wars I and II, the company made munitions such as hand grenades. In 1959, the company changed its name to Leesona—after its owner, Joseph Leesona.

# Three

# COMMERCE

For thousands of years, the Indians were engaged in trade. Objects such as wampum, made of shells, have been found many miles from the ocean and soapstone bowls have been discovered a great distance from the quarries from which they were mined. When Roger Williams was banished from Massachusetts Bay Colony, the Indians already respected him because of their past trading relationships. Therefore, the lands they gave him that were to become Providence and Cranston were located near several of their major trade routes so that the exchange of goods would continue.

The earliest European settlers in what is now Cranston were largely self-sufficient. Family farms provided most of their own food and people made their own clothes and most of their household goods. As time went on, Cranston residents began to specialize, and more people turned from farming toward selling merchandise and providing services to their neighbors. Each village had its own stores and businesses, run by blacksmiths, tailors, wheelwrights, and the like, to meet the needs of the local residents. Taverns and inns were built near major streets to serve travelers, and businesses were located near Narragansett Bay to cater to sailors and fishermen.

As roads were improved and public transportation became available, people no longer needed to confine their business dealings to just the residents of their villages. Stores and other service companies were clustered together along major streets and trolley lines. Rows of small, family owned businesses developed on thoroughfares such as Park Avenue, Rolfe Street, Broad Street, Warwick Avenue, Pontiac Avenue and Oak Lawn Avenue.

Now Cranston has destination shopping centers like Garden City and Chapel View that contain nationally known stores and restaurants. However, many residents still frequent the small, single-owner businesses along the streets that they travel every day.

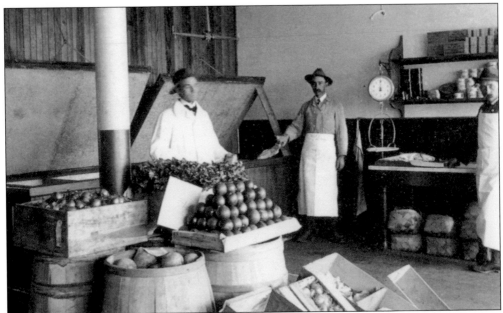

Although the large manufacturing concerns often led to great prosperity for their owners, most businesses in Cranston that sold goods or provided services were small and did well just to provide for a family. These businesses usually carried the proprietor's name, so he took pride in his work and provided the best customer service possible. Food stores often specialized in particular products. Ben Wilbour's market, seen in the photograph above, sold mostly produce, while the butcher shop in the photograph below sold primarily meat. Both of these Pawtuxet shops stocked canned goods and had several employees to wait on trade. The days of one-stop, self-service supermarkets were still in the future. (Courtesy of Henry Brown/Don Cameron Collection.)

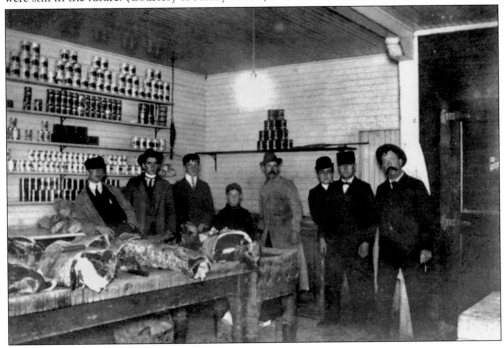

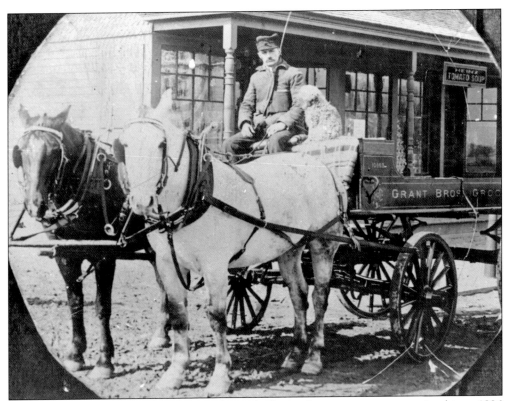

The Grant Brothers Grocers offered delivery by horse-drawn wagon, as seen in this c. 1896 photograph of the deliveryman and his best friend. In the background is the brothers' store, where a sign touts Heinz tomato soup. A pyramid of soup cans is visible in the display window.

Another local store was receiving goods delivered by a horse and wagon in this photograph of a similar vintage. G.E. Blanchard of 733 Park Avenue near the intersection with Greenwood Street in Auburn resold the fancy cakes and bread baked by the John Kennedy Bakery in nearby Providence.

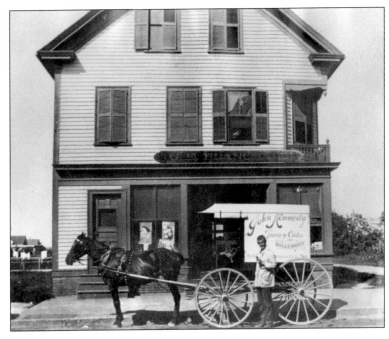

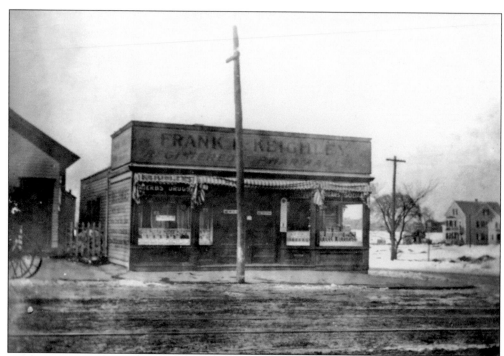

Pharmacies, originally known as apothecaries, proved to be a popular business, and every village seemed to have at least one. It was often more convenient for residents to seek medical advice from the pharmacist than it was to contact the doctor. The photograph above is of Frank Keighley's drugstore in Arlington on the corner of Cranston Street and Webster Avenue, and the photograph below is of Walter E. Watson's pharmacy. Although both stores boasted of a registered pharmacist to take care of the residents' health needs and fill prescriptions, they also advertised their tobacco products. (Below, courtesy of Henry Brown.)

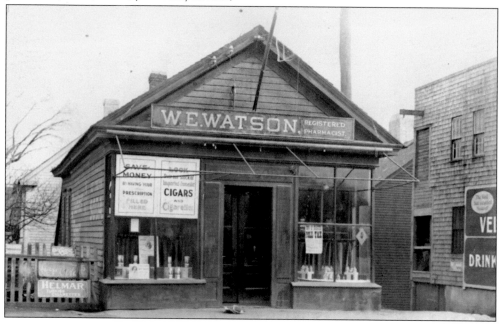

John Callery's store on the corner of Oak Lawn and Brayton Avenues was an important part of Oak Lawn village. The Callery family lived upstairs over the store that sold everything from candy to tobacco. Originally, the building also housed a blacksmith shop, but by the 1920s when this photograph was taken, the gasoline pump attracted more customers.

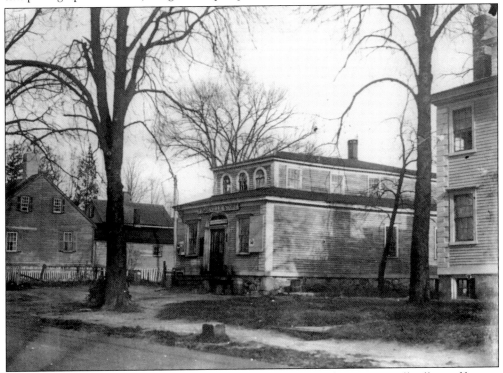

Fiskeville, located in the southwest corner of Cranston, started out as a small village of houses and farms. Later, a blacksmith shop, a carriage shop, and a few stores were built. Starting in 1812, factories opened on the Pawtuxet River and mill houses were added to the village. Dr. Daniel Baker built this store. (Courtesy of Donald Carpenter.)

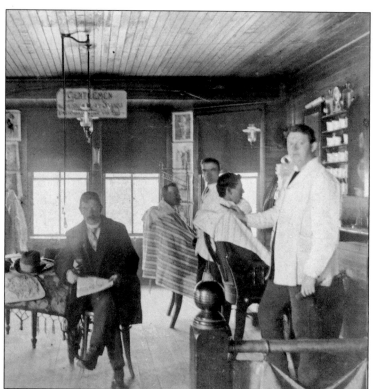

Some neighborhood businesses provided services rather than goods. This barbershop was located on the second floor of a building near the Pawtuxet Bridge. It operated around 1890, providing gentlemen with the luxury of a professional shave and haircut in an era of gas lamps and straight razors. (Courtesy of Henry Brown/Don Cameron Collection.)

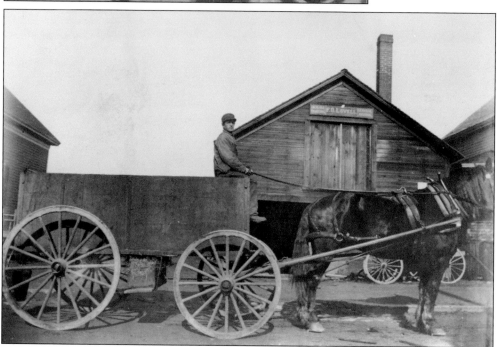

Fred Lovell, pictured in 1910 riding in his horse-drawn wagon, owned another kind of service business. Although the sign on the building behind him identifies his occupation as a house painter, the structure is unpainted. This establishment was on Greenwood Street, south of Park Avenue.

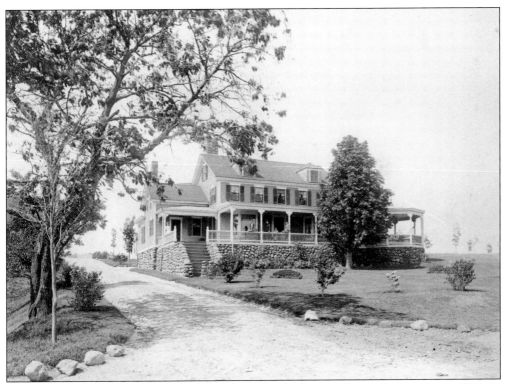

One of the most successful Cranston businessmen was John Morgan Dean, who was born in 1856. As a young man, he opened a home furnishings store in Providence with his brother-in-law. Eventually, Dean became the sole owner of John M. Dean Furniture Company, which was the largest store of its type in New England, and popularized the idea of buying on the installment plan. He developed the subdivision named Meshanticut Park, near this beautiful Oak Lawn Avenue home, which he had purchased in 1880. As a prominent Republican, Dean was instrumental in Cranston becoming a city, but he narrowly missed becoming the first mayor in the 1910 election.

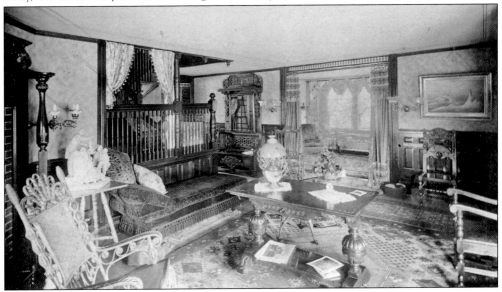

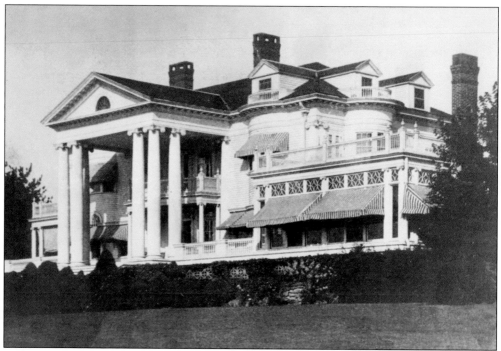

In 1904, Dean built an even more magnificent 20-room mansion on his farm at the top of Sockanosset Hill. He named the estate Tupelo Hill after a rare tree that he found on the grounds. Formal Italian gardens and a stone wall wide enough for a team of oxen to drive across it surrounded the mansion. The house burned down in 1934, and all that remains of the estate is a stucco carriage house that has been converted to a residence. The area is now an upscale residential enclave with streets named after the types of apples Dean raised on his farm.

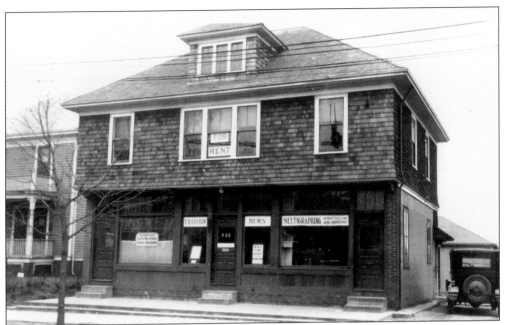

This building was located near the intersection of Park Avenue and Rolfe Square and was part of a group of small businesses that made Auburn one of the city's primary commercial centers around the beginning of the 20th century. The structure housed both the Cranston District Nurse's office and the *Cranston News*, a newspaper that doubled as a printing business.

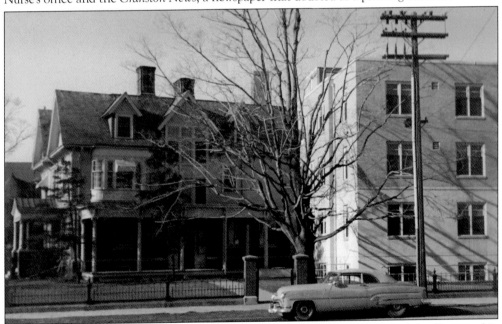

In 1933, some doctors purchased this mansion on Broad Street and started the Osteopathic Hospital of Rhode Island, with 6 doctors, 12 nurses, and room for 18 patients. Over time, five additions were added to the building. In 1971, the hospital was renamed Cranston General Hospital. It went bankrupt in 1993, and the site is now home to a Walgreens drugstore. (Courtesy of Larry DePetrillo.)

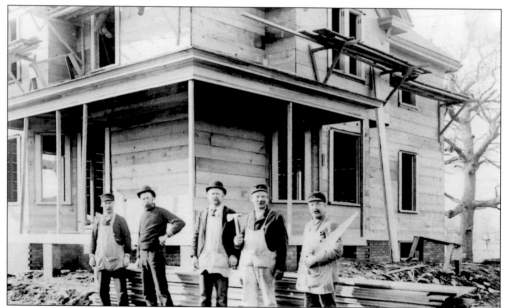

As housing subdivisions flourished along the public transportation lines, there was plenty of work for men skilled in construction. Around 1900, the Williams Brothers Construction Company built many houses in Eden Park as well as the original Phillips Memorial Church on Pontiac Avenue. (Courtesy of Anne Crocker [granddaughter of a Williams brother].)

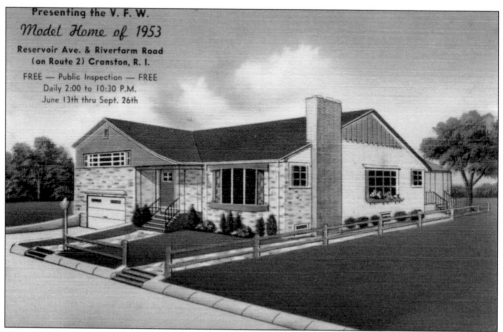

As the returning World War II veterans started to look for new homes for their families, construction boomed in central Cranston. Various real estate and development companies offered homes in new communities like Garden City and Woodridge. This model home for sale was farther north in Forest Hills. (Courtesy of Donald Carpenter.)

# *Four*

# GOVERNMENT

In the early years, people wanted a direct say in their local government through town meetings. Some services were privatized, such as building toll roads and proprietors' schools, as well as assigning the indigent and orphaned to local farmers to use as labor. Because the seat of government was in central Providence, people in what is now Cranston had to travel long distances in order to attend town meetings and conduct official business. For this reason, the area broke off from Providence and incorporated as a separate town in 1754.

Over 100 years later, Providence gained some of this land back by annexation and used other Cranston property for its benefit. Its proximity to Providence resulted in Cranston becoming not only a residential suburb for people who worked in Providence but also the site of the area's reservoir and pumping station in 1871. Reservoir Avenue was constructed along the pipeline that carried the water from the Pawtuxet River into Providence. At about the same time, the nearby Howard and Brayton farms were purchased to become the site of state institutions for the indigent, insane, and criminal, many of whom were from Providence. Starting in the 1870s, this area near Sockanosset Hill became home to the state prison, insane asylum, almshouse, and boys' training school.

As Cranston struggled to finance roads, public safety, and schools, the question of development versus low taxes resulted in incorporating as a city in 1910. Over the years, that dispute has continued. Projects for sewers and water pitted people in the eastern areas that would benefit against the rural sections of the city that would not have these municipal services for many years. This divide between the older east and the still developing west has continued, since they often have different populations and priorities.

After Cranston was incorporated as a separate town, the first town meeting was held on June 25, 1754, in the meadow behind the William Burton house on Wilbur Avenue in Oak Lawn. There, the first town officials were elected, including Burton as both town clerk and justice of the peace. The Rose Cottage, as it was known, was later demolished to make way for Interstate 295.

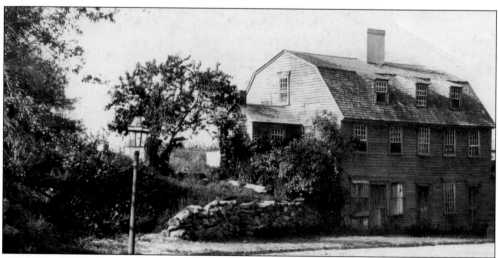

Caleb Arnold's tavern on Phenix Road became the first site for the town council meetings. Other early locations for these meetings were Nehemiah Knight's tavern in Knightsville and Jeremiah Williams's tavern, where Briggs School was later built. Taverns were a popular meeting place since they served ale, which probably contributed to the rowdy nature of some meetings.

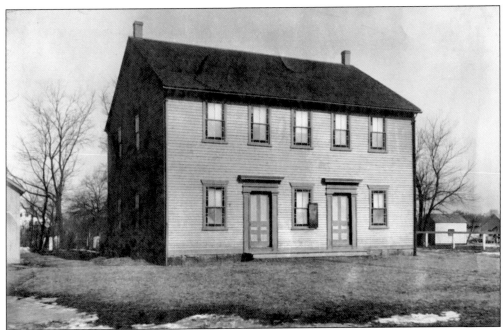

Although the Knightsville meetinghouse was built in 1807 as a Baptist church, the congregation allowed Cranston to use it for town meetings. They were held regularly at this site for nearly 50 years and intermittently thereafter until 1879. During this latter period, the location for the town meetings alternated with sites in eastern Cranston to appease the people of that area.

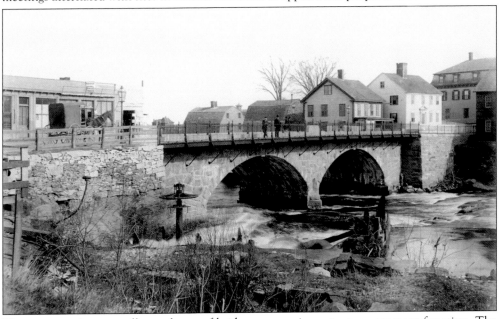

The construction, as well as upkeep, of bridges was an important government function. The Pawtuxet River Bridge, seen in this 1880 photograph, was a source of friction between Cranston and Warwick since it straddled their shared border. First built in 1711, the bridge was replaced several times, but in 1803, it was in such disrepair that Cranston was indicted for neglect. Finally, the two towns agreed to jointly maintain the bridge. (Courtesy of Henry Brown.)

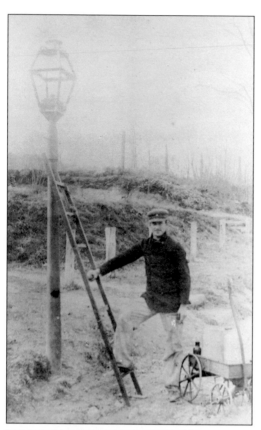

Although the town did not supply many of the services that are now taken for granted—such as water, trash removal, and sewers—a valuable service was provided by the lamplighter. Charles Armstrong worked in the Oak Lawn area, and each day at dusk, he would light streetlamps and extinguish them at dawn.

Pawtuxet played an important role in the events leading to the American Revolution. When the HMS *Gaspee*, which was harassing Rhode Island ships, got stuck on a sandbar, a group of men in rowboats shot the captain and burned the ship. The captured sailors were brought to the Aborn Tavern, seen in this 1953 photograph.

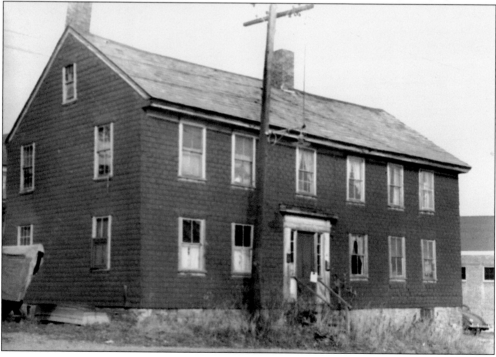

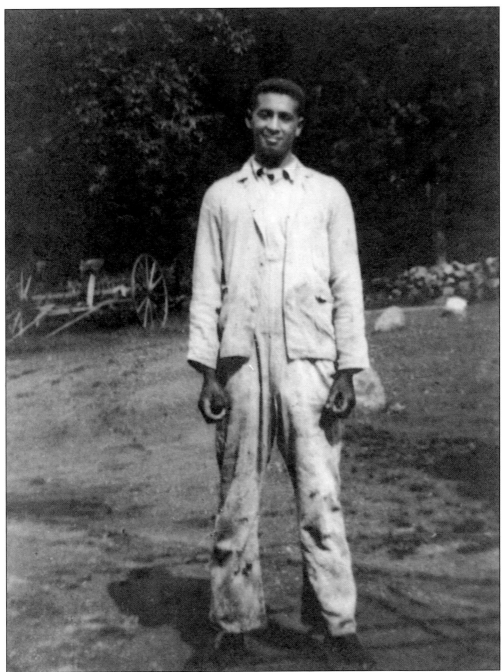

Although Rhode Island voted to abolish slavery in 1652, this law was ignored until 1784, when the state legislature voted to gradually end the practice. During the American Revolution, Cranston paid slave owners 44 pounds to free a slave for service in the army. While slaves were never a large presence in Cranston, 10 slaves, owned by prosperous landowners with well-known Cranston names like Lippitt and Knight, are listed in the 1790 Census. There are also 67 free nonwhite persons, many of whom were probably freed slaves. Identified as Creeg, this man, a descendant of slaves, lived at Rivulet Farm in Oak Lawn. (Courtesy of Linda Shaw.)

# REPORTS

OF THE

# TOWN TREASURER

AND OF THE

# Overseer of the Poor,

OF THE

## TOWN OF CRANSTON,

## MADE TO THE APRIL TOWN MEETING IN

## 1859.

PROVIDENCE:
BRADFORD, MILLER & SIMONS, STEAM PRINTERS.
1860.

In the early days, Cranston auctioned off the care of the poor to their neighbors. Since the low bidder won, there was no incentive to meet more than their basic needs. In 1839, the town purchased a farm where present-day Meshanticut Valley Parkway meets Oak Lawn Avenue and built an almshouse with a separate space for the insane. In this 1859 report, Olney Arnold, the overseer of the poor, states that each inmate costs 97¢ per week, for a total of $1,457. Since farm income was only $522, the asylum ran a deficit. Arnold also proudly reports that 85 people were assisted to move away, some of them as far as Canada. By 1890, the four remaining inmates were sent to the state institutions, and Cranston's poor farm was closed.

Cranston contributed greatly to the Civil War effort. When President Lincoln issued his call for volunteers, Cranston offered a bounty of $500 to every man who enlisted and then paid $1 a week to their wives and 50¢ per child. Cranston's William Sprague IV, seen in the photograph at right, was governor, and he personally recruited prospective soldiers and then outfitted them for the army. Sprague was instrumental in the Battle of Bull Run and had two horses shot out from under him. Many viewed him as a war hero, and he became a favorite of the president, who attended his 1863 wedding to Kate Chase, the daughter of Secretary of the Treasury Salmon Chase. This was the same year Sprague was elected as a US senator.

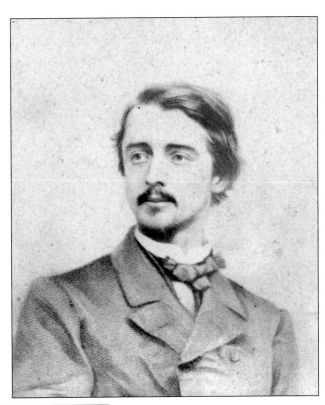

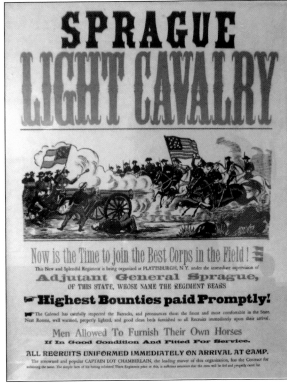

Sprague used posters such as this one to recruit volunteers with the lure of high bounties.

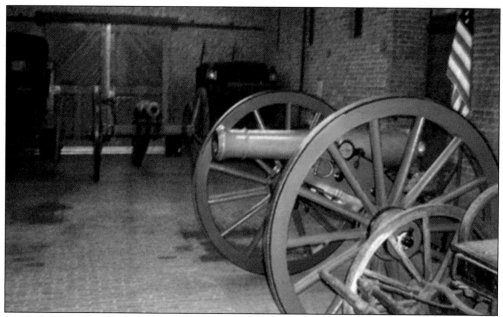

Just before the Civil War, William Sprague acquired 18 cannons so that local artilleryman could train on them. In 1924, the city displayed three of them on Memorial Monument Square near city hall. The National Guard removed these canons, capable of firing six-pound balls, in 1988. Seventeen years later, two of the canons were returned to Cranston and are located in the Sprague Carriage House, as shown in this photograph. (Courtesy of Gregg Mierka.)

MR. TAXPAYER:

If you are opposed to high taxes, increased valuations, wasteful extravagance and robbery of your rights by the City Charter we invite you to vote for the candidates selected by us.

CRANSTON TAXPAYERS ASSOCIATION
WARD 4.

| REPUBLICAN | DEMOCRAT | |
|---|---|---|
| FOR MAYOR. | FOR MAYOR. | FOR MAYOR. |
| John M. Dean, Oak Lawn Avenue. | Edward M. Sullivan, 42 Nichols Street. | |
| FOR COUNCILMEN. | FOR COUNCILMEN. | FOR COUNCILMEN. |
| Earl P. Irons, 1559 Cranston Street. | Daniel F. Searle, Hope Road. | |
| Edwin T. Westcott, Plainfield Street. | Henry L. Pratt, Oak Lawn. | |
| J. Titus Andrews, Budlongdale Road. | John H. Barry, 50 Haven Avenue. | |
| William H. Congdon, Wilbur Avenue. | Charles H. Stone, Major Flynn Farm. | |

The first mayoral election in 1910 was a hotly contested race between John Dean, a wealthy Republican businessman, and Edward Sullivan, a Democratic lawyer. This Cranston Taxpayers Association handbill tries to convince voters that electing Democrats would prevent high taxes and wasteful spending. The public must have agreed, because Sullivan unexpectedly won the election by 31 votes.

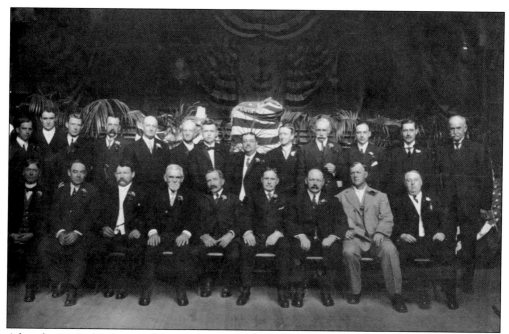

After the 1910 election, the Democratic-controlled city council usually backed the Democratic mayor. But not long after this 1913 photograph was taken of the city council, Sullivan lost an election to Republican John Horton. During Mayor Horton's tenure, the Republicans captured the city council by a large majority and kept control until the Depression.

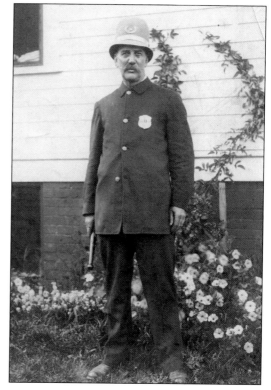

Protecting Cranston's citizens was an important government function. The early members of the police force used horses or bicycles to chase down criminals or runaway livestock. Policeman Charles H. Smith, seen here, had badge No. 9. Unfortunately, the police department sometimes got involved with politics. Mayor Sullivan had three police chiefs in two years.

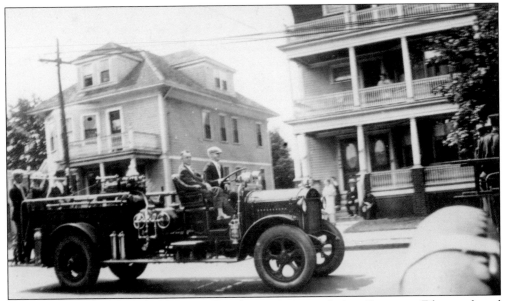

Many sections of Cranston had a volunteer fire company, including Pawtuxet, Edgewood, and Oak Lawn. They went from using horse-drawn apparatus in the 1800s to having advanced to mechanized equipment after 1900. By the 1920s, there were 11 companies, including the one in Eden Park that owned this 1927 truck. (Courtesy of Anne Crocker.)

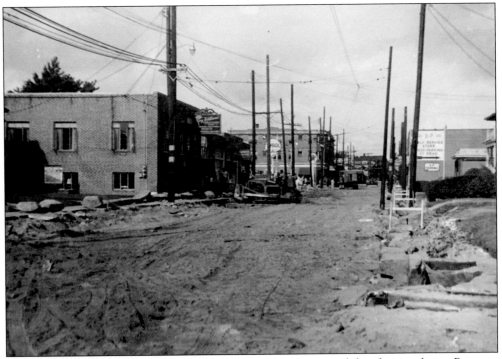

The building and maintenance of roads was a municipal responsibility from early on. Property owners could repair their adjacent roads in lieu of paying taxes with the result that roads were not uniform. In 1951, when this photograph was taken of Park Avenue at Grace Street, the city was widening this increasingly busy east-west artery.

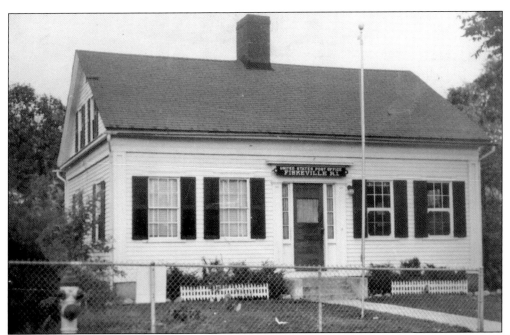

Even small villages wanted their own post offices. They were often gathering places where neighbors exchanged news and gossip as they picked up their mail. The Fiskeville Post Office was located on Main Street, which was the border between Cranston and Scituate, so it served both communities. When this photograph was taken in 1953, Isabel McShane was postmistress.

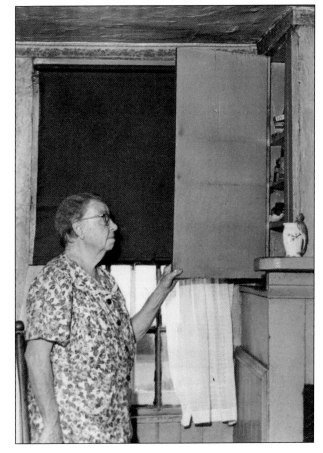

Sometimes, the village post office was just a part of a building, and it had to share space with other enterprises like a general store. Certainly the smallest post office "facility" in Cranston was this cupboard located in a building at 1609 Cranston Street. The woman in this photograph is Geneva Warburton.

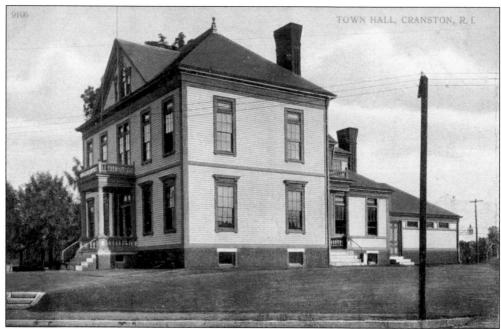

In 1886, the town hall (seen above) was built at the intersection of the three main roads in the center of Knightsville—Cranston Street, Park Avenue, and Phenix Avenue. Although the Democrats wanted the seat of government to remain in Knightsville and the city planning commission wanted to build in Oak Lawn, the Republicans succeeded in getting the new city hall sited farther east on Park Avenue in Auburn, next to the high school, in 1936. The building (pictured below) was constructed using funds from the Works Progress Administration (WPA). Its location in Auburn solidified this section as the civic center of the city.

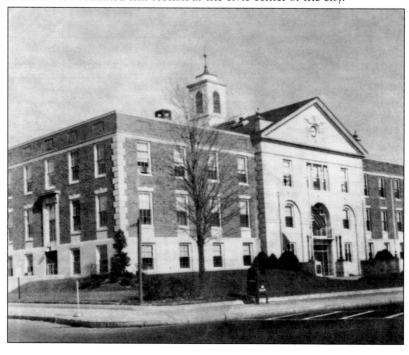

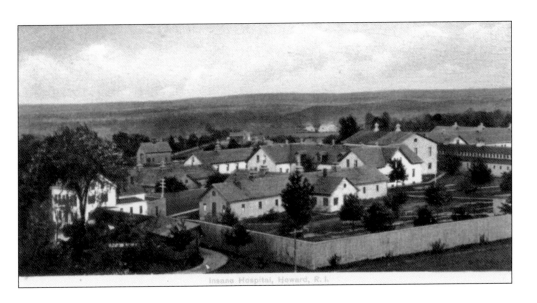

In the 1860s, the state bought two adjacent farms in Cranston—the Stukeley Westcott farm, owned by Thomas Brayton, and the William Howard farm. Over the next few decades, the state institutions at Howard included numerous buildings to house Rhode Island's poor, insane, and criminal citizens. The first wood-frame structures were later replaced with buildings made of the stone quarried on the farm by the inmates. The c. 1905 photograph above shows the Insane Hospital, as it was called at the time, and the photograph below depicts the state prison and county jail. It was thought that the inmates would benefit from a pastoral setting away from the social ills of the city; farming the land or working at various trades would make them better people. (Both, courtesy of Donald Carpenter.)

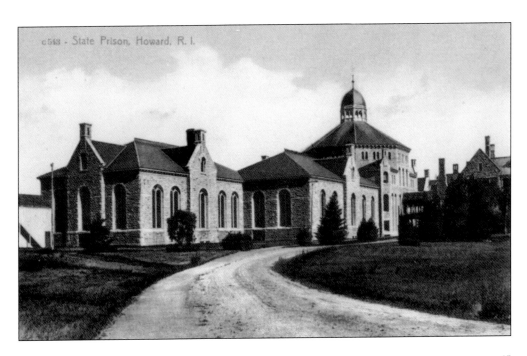

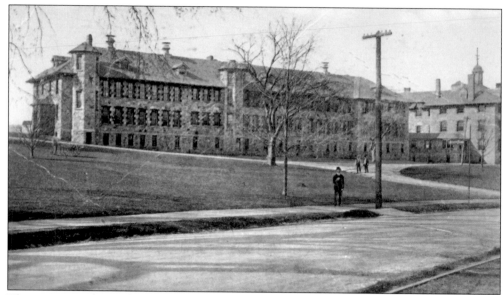

The state-owned complex also included an almshouse for the paupers who could not support themselves. Many of the residents were mentally or emotionally challenged, but some were just too old or sick to work. The repair of Route 37 in 2009 disturbed the cemetery where many of these unfortunates were interred. Only brass nameplates and bones remained.

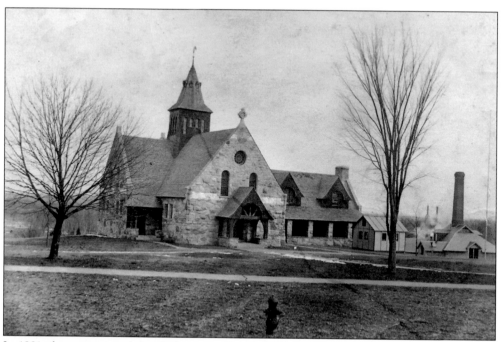

In 1881, the state created the Sockanosset Boys School. Instead of in one massive building, the boys lived in separate, more homey cottages. Many of the early inmates were poor urban youths who hopefully could be saved if taken out of their chaotic environments. This chapel and infirmary building was constructed in 1891. (Courtesy of Larry DePetrillo.)

Providence's government officials turned to Cranston for the city's drinking water in 1868. The Pawtuxet River was dammed, and a pumping station, seen in the c. 1920 photograph at right, was erected in the village of Pettaconsett to raise the water into a 14-acre reservoir on top of Sockanosset Hill, across the street from the boys' school. Pipes were laid going into Providence, and Reservoir Avenue was constructed along the right-of-way. The photograph below depicts the interior of the pumping station and some of its massive machinery. In 1926, the construction of the Scituate Reservoir ended Cranston's reservoir operation.

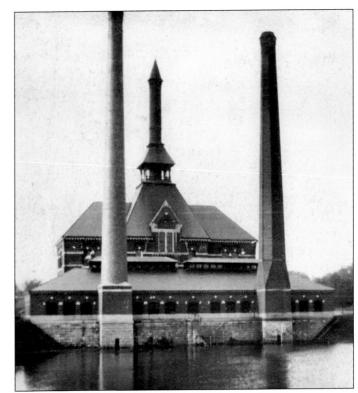

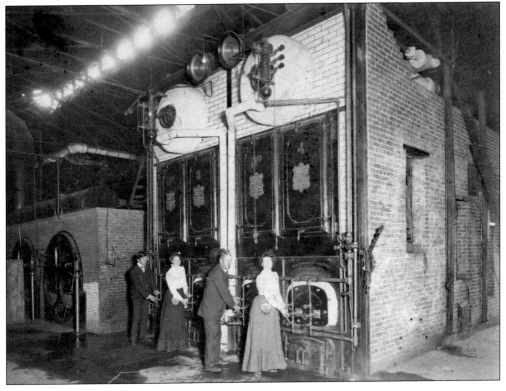

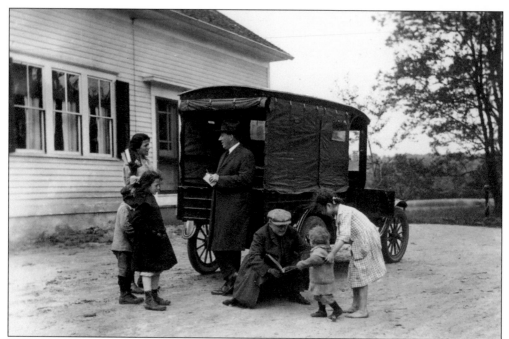

At first, private associations in Oak Lawn, Knightsville, Auburn, Arlington, and Edgewood owned libraries. By the 1970s, all of these libraries became part of the Cranston Library System, and later, a central library was built in Garden City. Libraries encouraged people to read, including bringing books to them. In front of the Oak Lawn bookmobile, G. Elmer Lamphere (standing) and Jonathan Comstock show books to neighborhood children.

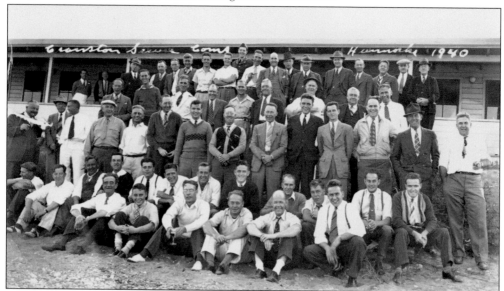

Sewers had been discussed for decades before the Sewer Act of 1939 finally made it a reality. Initially, the project was heralded as an engine of economic growth that would raise property values. But it quickly became unpopular as construction delays and cost overruns occurred. This 1940 photograph shows some of the men involved in building the sewers. (Courtesy of Virginia Browning.)

*Five*

# EDUCATION

The first Cranston schools were private. These early schools were called proprietors' schools, and they were built and supported by the students' fathers. Teachers were paid about $1.50 per week and were often expected to board with the students' families. Men usually taught the older boys in the winter, and women, hired at a lower price, instructed the small children and girls in the summer.

In 1828, Rhode Island passed a law making public education mandatory. Cranston formed a school board and divided the town into 11 districts, each with one school. As time went on, the number of schools varied as new areas were developed, small schools were consolidated, and Providence annexed sections of eastern Cranston. Because of the widely dispersed population, schools in the western part of Cranston were often one room with all the grades taught by the same teacher. In the more densely populated eastern portion, the schools divided the students by grade. Eastern Cranston also had grammar schools, and in 1892, the first high school was established.

A 1954 survey of the city's 25 schools revealed the oldest school still in use was Lippitt Hill, built in 1858. The rest ranged from the wooden schools built around 1900 (such as Norwood Avenue, Highland Park, and Clarendon Street) to the brick, multistoried schools built during the 1920s and 1930s (such as Bain, Rhodes, and Waterman) to the more modern one-story buildings that were constructed in the suburban housing developments during the early 1950s (such as Stadium, Garden City, and Woodridge).

Currently, Cranston has 2 high schools, 3 middle schools, and 17 elementary schools housing nearly 11,000 students. Briggs, built in 1905 and now part of Cranston East, is the oldest school building still in use, and the newest, Orchard Farms, was erected in 2002.

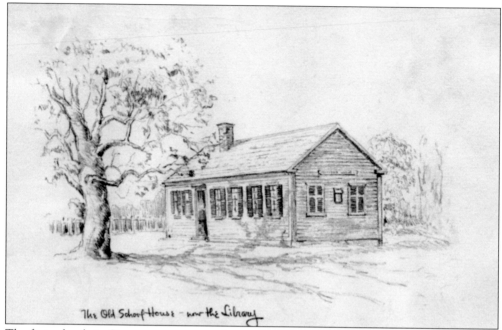

The Old School House - now the Library

The first schools in Cranston were privately owned proprietors' schools. The Oak Lawn School in this print was originally located near where the current-day Routes 2 and 5 converge. Around 1840, the building was moved to its present site on Wilbur Avenue. In 1895, when a larger school was constructed on Stoneham Avenue, the original building became a library still in use today.

In 1815, two sisters, Waity and Emma Arnold, opened this proprietors' school in the Edgewood building that their father, Nicholas Arnold, had built across from where the William Hall Library is today. Later, after the state mandated free public schools in 1828, another school was started at the corner of Park and Warwick Avenues. That building eventually became the Edgewood Library.

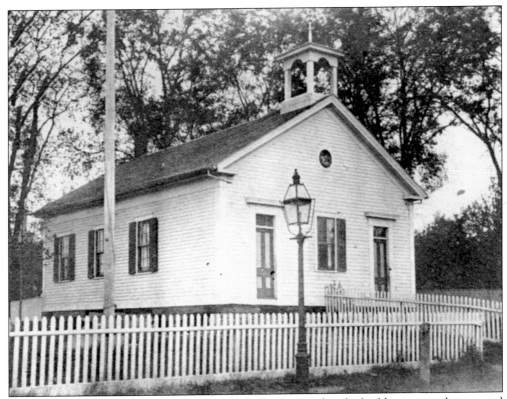

The Red Schoolhouse was built in Pawtuxet in the 1830s. After the building was no longer used as a school, the newly formed Pawtuxet Volunteer Fire Company bought it for $50 in 1891. The former school was moved to Commercial and Sheldon Streets, and a garage for the fire apparatus was constructed under the original schoolroom. It was Cranston's first volunteer fire station.

The four-room Norwood Avenue School was built in 1892. In 1908, another school building was erected next door that had 10 classrooms. The smaller building became the primary school while the bigger building housed the older students. In 1954, with the opening of Park View Junior High, the primary school was closed, and all elementary classes were held in the 10-room school.

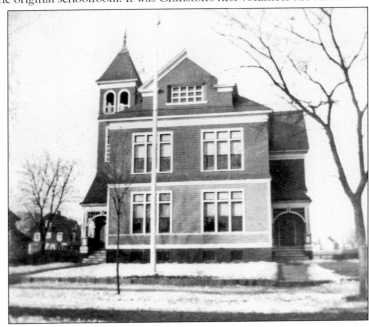

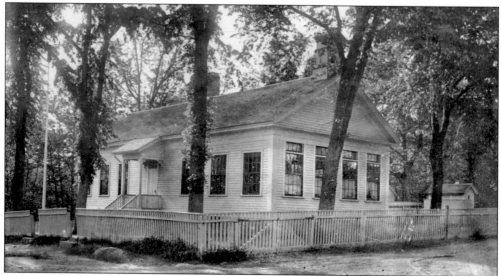

Lippitt Hill School, near Hope Road, was typical of the rural schools in western Cranston. This two-room wood-frame building was erected in 1858. By 1953, only 58 students were enrolled, and it closed five years later. Now the residence of a Cranston teacher, the school retains many of its original features.

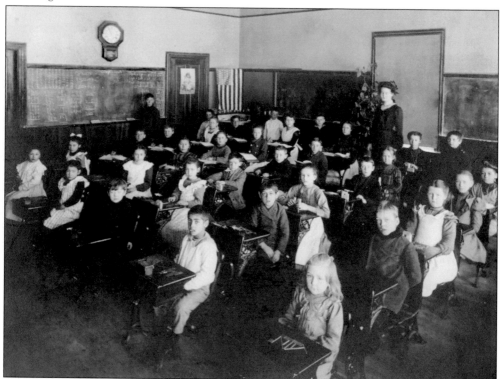

This interior shot of Lippitt Hill School, taken around 1920, shows a classroom of younger children. Although the class has over 35 students in perhaps four grade levels, there is only one teacher, who received a yearly salary of about $1,290. The classroom is sparingly equipped, but the blackboard is evidently well used by teacher and students alike.

The Pippen Orchard School was built in the mid-1800s. Like many schools of the times, it has separate entrances for the boys and girls. In the 1920s, a newer school on land donated by Frank Knight replaced this building. Knight later bought the old building for $1 and brought it to his farm for a garage, seen in this photograph.

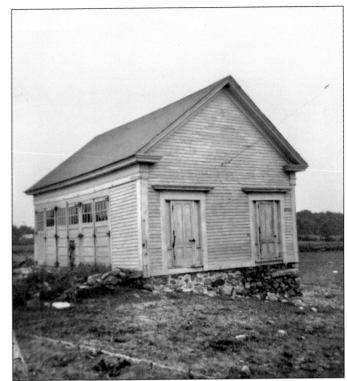

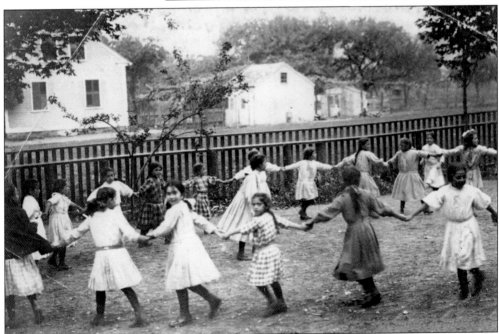

For many children, the best part of the school day was recess, where they happily took part in group games. These students are taking advantage of the nearly 1.5-acre lot that Knightsville School was built on in 1916. Most of the schools at this time were constructed on much smaller parcels of land. Not until the 1950s were big schoolyards common.

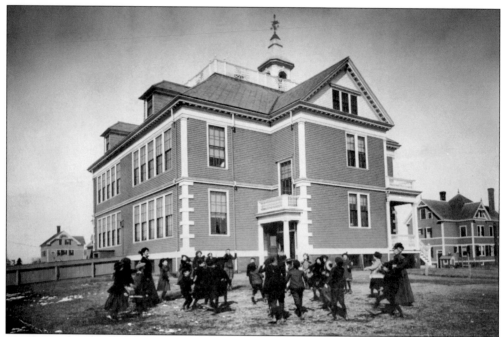

The Eden Park School, located on Pontiac Avenue, was built in 1897. In his report of 1919, the school superintendent mentions that because of increased enrollments, classes throughout the city are being held in storage rooms and divided assembly halls. Consequently, an addition to Eden Park was constructed in 1920. In 1952, this building was replaced with a one-story stone school on Oakland Avenue.

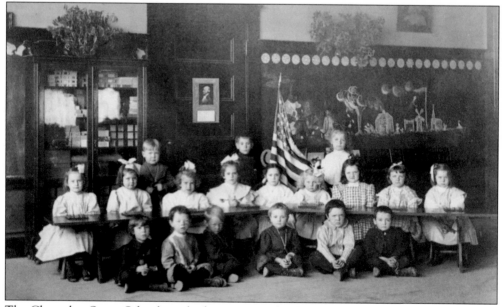

The Clarendon Street School was built in 1908 and enlarged in 1929. It housed kindergarten through the sixth grade in eight attractive classrooms. In this 1910 photograph, the third boy from the left in the first row is Harold Williams, a descendant of Roger Williams. The two-story wood building was demolished in 1961. (Courtesy of Anne Crocker [Harold's daughter].)

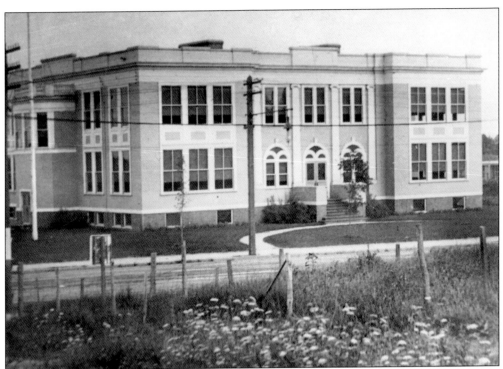

Unlike the rural schools where kindergarten through the eighth grade were all part of the same school, in the more densely settled eastern area of Cranston, the grammar school was often in a separate building. This allowed the school to offer a more varied curriculum that better prepared the students for high school, if they decided to continue. The Arlington Grammar School for the fourth through eighth grade is seen in the photograph above. In the photograph below, taken in 1891, the well-dressed pupils of this same school pose with their male teacher, who received a substantially higher salary than the mostly female grade school teachers.

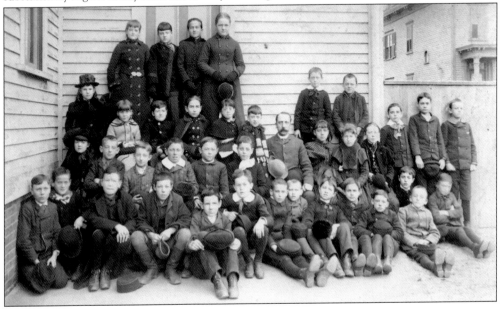

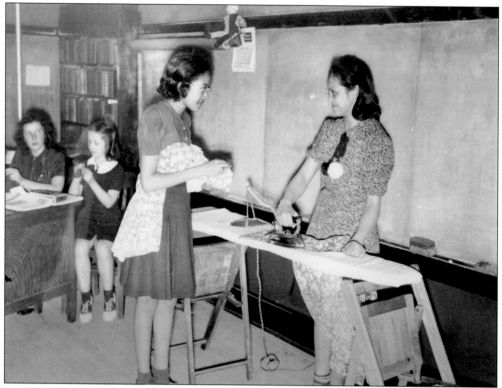

By the 1920s, the school district had added classes in the domestic and manual arts for grammar school students, with special teachers hired to instruct them. The girls in this class at Meshanticut Park School learned the intricacies of ironing and knitting. Boys in the same school learned useful skills such as shoe repair.

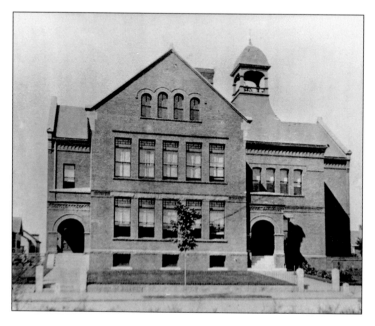

Up until 1891, Cranston students went to Providence for high school. When lack of space stopped this arrangement, high school classes were added to a few Cranston grammar schools, including the Auburn Grammar School, seen in this c. 1900 photograph. In 1892, Cranston converted this school into its first high school. Twelve years later, the high school classes moved out, and in 1907, the building burned down.

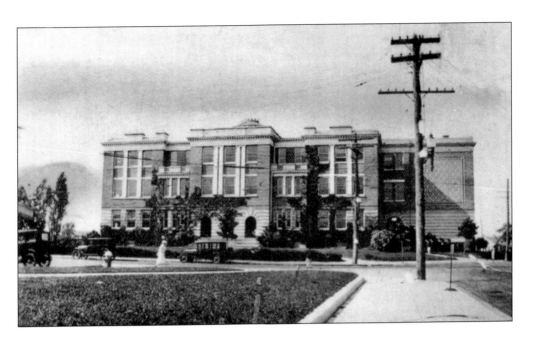

In 1904, a new Cranston High School, seen in the photograph above, was built on Park Avenue, but after 11 years it was deemed too small and became the Briggs Junior High School, named after Rev. William Briggs, who was a Baptist minister and the superintendent of Cranston Schools. It was used as a junior high until 1954, when Park View opened. Now, the Briggs building houses the district administration offices on the first floor, and the two upper floors are used once more for high school classrooms. The 1904 photograph below shows some students who attended the high school the first year that it was open.

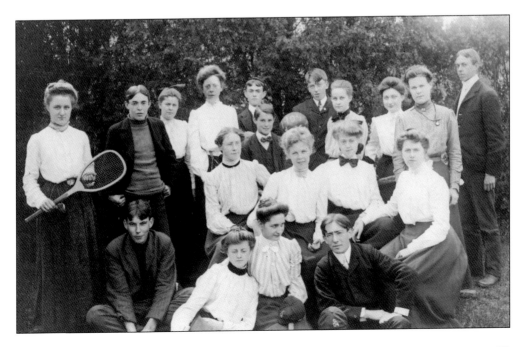

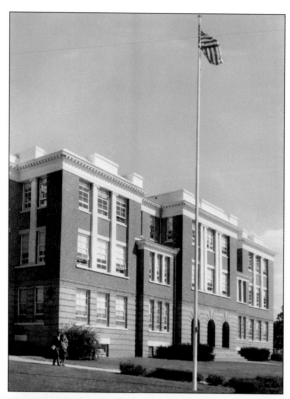

In 1925, a much larger high school was erected on the opposite side of city hall from Briggs. Various additions have been built over the years to provide students with more modern facilities. In 1960, when a second high school was built across the city off Phenix Avenue, the two schools added East and West to their names.

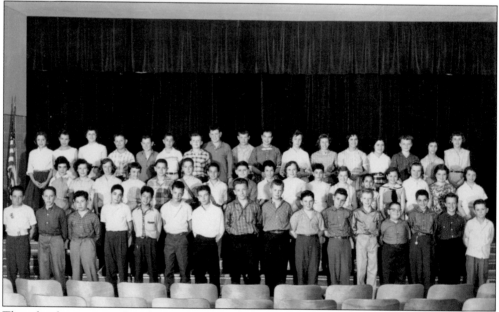

The schools constructed in the 1950s for the postwar baby boom were very different from earlier schools. Built in the suburbs where there was more room, the one-story schools featured large schoolyards and multiuse cafeterias/gyms. Stadium School, built in 1953, was the first elementary school to have a separate auditorium with fixed seating and a stage, which is being used in this photograph by the class of 1959. (Courtesy of Virginia Browning.)

# *Six*

# TRANSPORTATION

The earliest inhabitants of the area did most of their traveling by foot or, since many of them settled near water, by boat. Horses came later and were used more by farmers than by people in the more densely populated sections. There, only the wealthy had room for carriage houses and stables on their large properties.

The town was responsible for funding its own roads, which were often in terrible condition. Private companies built turnpikes for which travelers would pay a toll in order to use an improved road that took a more direct route. Cranston had several such toll roads that connected the settlement to Providence, Coventry, and South County.

The next innovation in transportation was the train. The first railroad, Providence & Worcester, started in 1847; eventually, several railroad companies serviced Cranston. Getting a train depot meant that sleepy little farming villages would grow rapidly as new residents arrived to be near better transportation. Horse-powered trolley cars made for easier travel from Providence to the Pawtuxet, Elmwood, and Spragueville sections of the town. Starting in 1893, electric cars linked Providence to Knightsville and then Auburn, Eden Park, Pawtuxet, and Oak Lawn. Public transportation made it easier for people to work in Providence but live in less crowded Cranston.

Nothing freed the individual to travel where and when they wanted like the bicycle, which became popular with the masses in the 1890s. Riders could live farther from their work, and they could spend their leisure time in rural areas. The advent of the automobile provided even more convenience. As automobiles became more commonplace, roads were paved, and new businesses arose to service them, including gas stations and car dealers. Suburbs began to grow in places that were not serviced by public transportation. Interstates 95 and 295 bisected the city to accommodate the growing number of drivers.

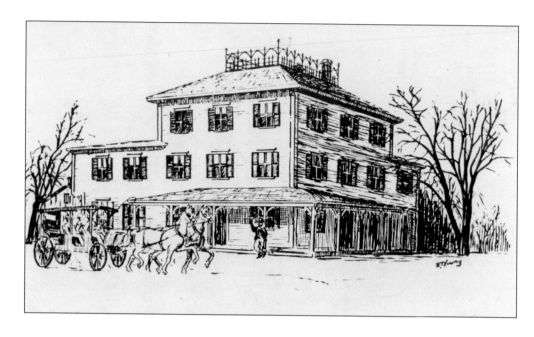

The building of turnpikes resulted in increased long-distance travel and the need for places to eat and stay overnight. The stagecoach made two stops in Cranston. The first was at Sandy Fenner's Hotel, depicted in the E.T. Young print above. This hotel was located at the corner of New London Turnpike and Knightsville Road, now Reservoir Avenue and Park Avenue. It was demolished in 1934, and the site later became the location of Lindy's Diner and then a gasoline station. The second stop was at the Gorton Arnold Stand farther along the New London Turnpike in Oak Lawn, seen in the photograph below. Later, Meshanticut Green and then 99 Restaurant were located at this site.

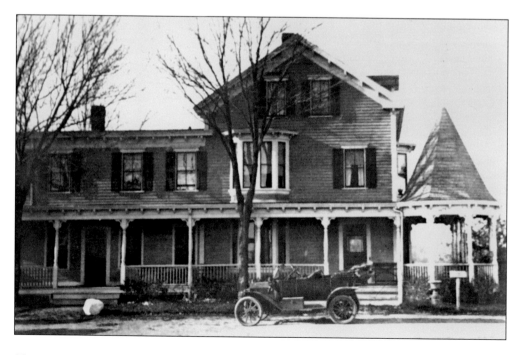

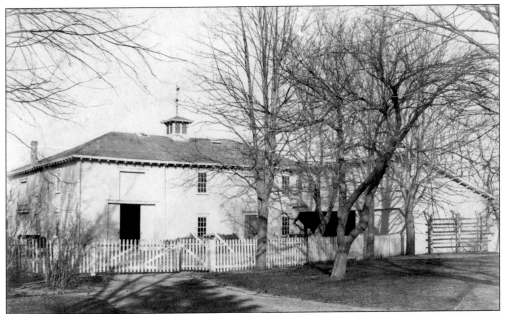

While most nonfarm people did not have the money or room to keep their own horse and carriage, estates like the one owned by Edward Taft included this spacious carriage house. Taft was the treasurer of Ponemah Mills and built a summer residence on Broad Street in Edgewood. His land overlooked Stillhouse Cove and the Rhode Island Yacht Club.

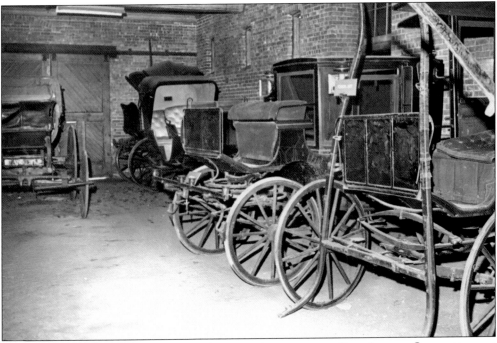

The Sprague family had a large carriage house on its property on Dyer Avenue. One section was a stable for the horses, and the two-story section held the horse-drawn vehicles. The Cranston Historical Society, which uses the adjoining Sprague Mansion as its headquarters, has numerous carriages and buggies stored in this building.

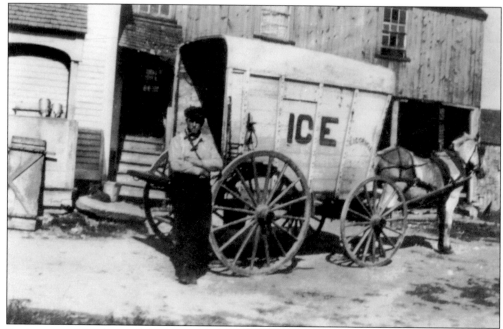

Businesses quickly learned the value of a horse and wagon. If many of the prospective customers could not easily go to the business, then that establishment made deliveries. This wagon, posed in front of the Cornell barn, allowed the owners to transport ice, which was a necessity for any dairy farmer. (Courtesy of Martha Cornell.)

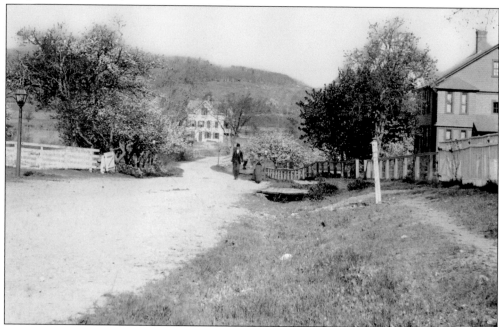

Even as the 20th century approached, walking was still the best way to travel small distances for most people. In this 1894 photograph, Will and Nellie Congdon can be seen walking past the Jenkins and Armstrong houses on an unpaved Wilbur Avenue in Oak Lawn. (Courtesy of Oak Lawn Baptist Church.)

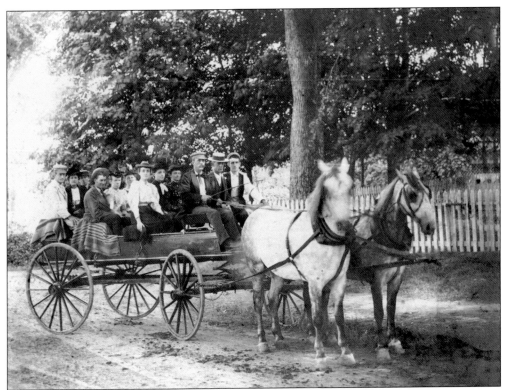

When people could not afford to have their own horse and wagon, they gratefully accepted rides in vehicles belonging to others. This group of a dozen well-dressed people rides in a four-row carriage down a dirt road in Oak Lawn. These large carriages were popular for sightseeing.

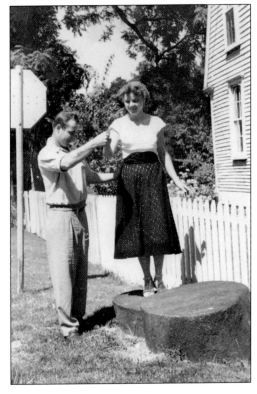

As demonstrated by a couple in this c. 1950 photograph, stone horse blocks allowed people in high carriages or stagecoaches to disembark in safety. These mounting blocks were located at the corner of Wilbur Avenue and Natick Road in Oak Lawn for many years, but they are now situated outside the Carriage House on the Sprague Mansion grounds.

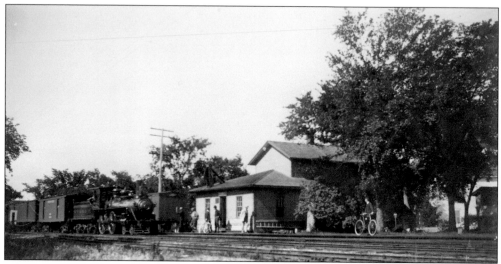

Having a train station often resulted in more population and importance for a village. A train from the New York, New Haven & Hartford Railroad is seen pulling up to the Oak Lawn railroad station, located on Exchange Street. In 1900, around the time this photograph was taken, Teddy Roosevelt made a stop at this depot during his trip to Rhode Island.

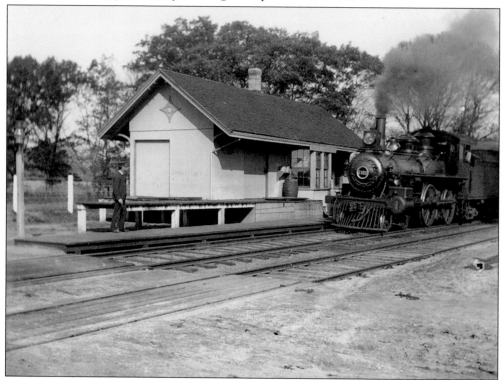

The Sockanosset railroad station was located near the corner of Sockanosset Crossroads and Pontiac Avenue. In this c. 1905 photograph, a 1895 Mason Locomotive Works steam engine from the New Haven Railroad has pulled into the station, which was useful for bringing supplies to the Sockanosset Boys School. The building later became a church and was eventually moved to Buttonwoods. (Courtesy of Donald Carpenter.)

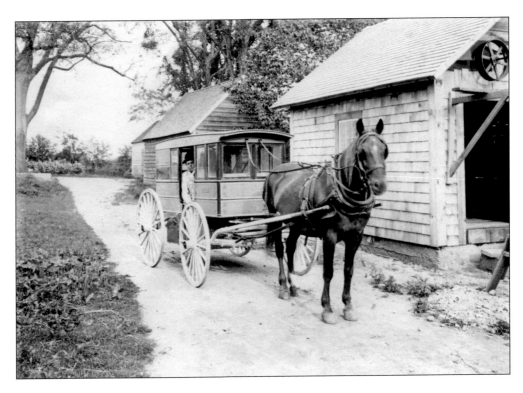

Horses and wagons remained a valuable means of transportation in rural sections of Cranston long after railroads and trolleys served the more densely populated parts. Farms often continued to use horse-drawn vehicles when they could not afford more modern trucks. In the photograph above, the Hervey Farm uses a horse and wagon to transport people, supplies, and products to and from market. In the 1923 photograph below, an overloaded hay wagon descends Apple House Hill on its way to the market in Providence. The street shown is Scituate Avenue near the location of the Arrow Lakes Dairy.

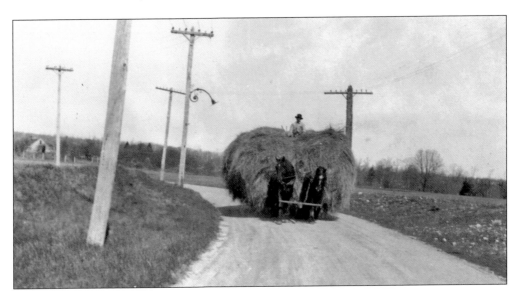

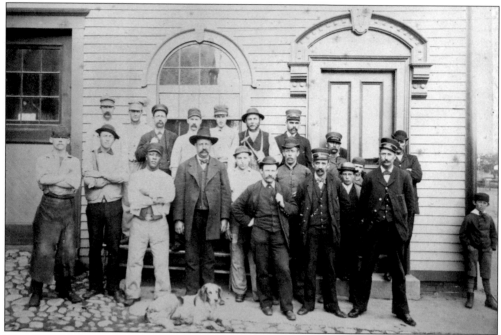

The Sprague family started a line of horse-drawn trolleys, called the Providence & Cranston Railroad Company, in the mid-1860s. Although their main purpose was to carry freight from the Sprague mill to the railroads in Providence, the trolleys did carry passengers. The barn for the horses and trolleys was located across the street from the mill. These workers are posed outside the barn in this 1880 photograph.

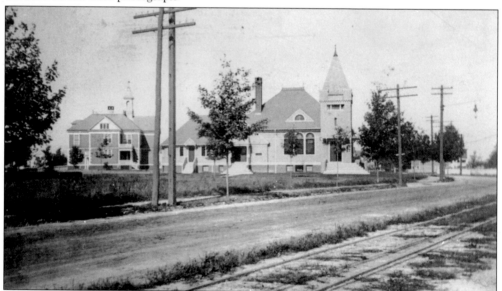

The electric trolley connected Cranston to Providence starting in 1893 and led to a construction boom in the residential suburbs near the two communities' border. As seen in the foreground of this c. 1910 photograph of Pontiac Avenue, the tracks for the trolley were installed in the paved street. The buildings are, from left to right, Eden Park School and Phillips Memorial Baptist. (Courtesy of Anne Crocker.)

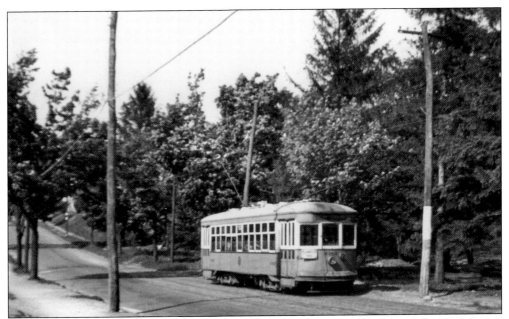

As seen in this 1935 photograph taken on Dean Street, the electric trolley served the Meshanticut Park area and helped to make this residential subdivision popular with commuters. The electrical power came from overhead lines. By the 1940s, these trolleys were being phased out by diesel-fueled buses that could travel where there were no wires.

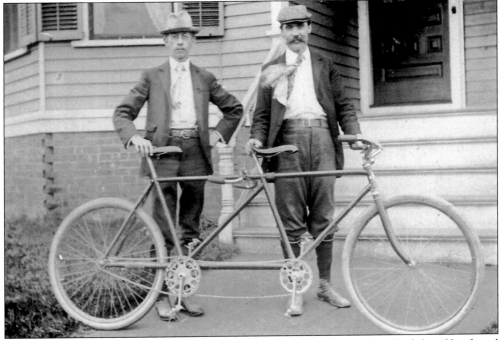

This bicycle sports two sets of handlebars and pedals that allow George Dyer (right) and his friend to ride together. Unlike earlier bicycles that had a much larger front wheel, this safety bicycle allowed the rider to put his feet on the ground to avoid tipping over. The trousers tucked into boots prevented the cloth from becoming entangled with the pedals. (Courtesy of John Dyer.)

With bicycles providing the personal freedom to go where one wanted, people who lived in the built-up areas of Cranston could enjoy the great outdoors farther west. In this c. 1895 photograph, George Dyer is accompanied by his future wife, Annie Florence DeWitt (center), and an unidentified friend. (Courtesy of John Dyer.)

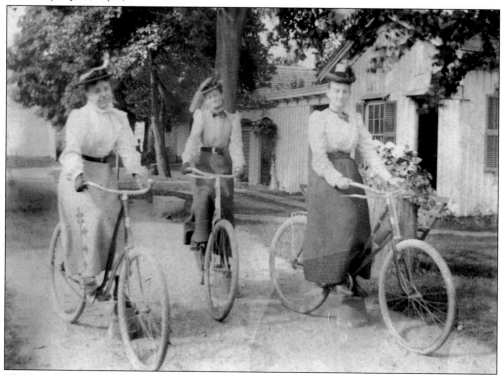

The bicycle craze of the 1890s meant greater mobility for women. In 1894, only five percent of bicycles were sold to women, but within a year, they were making 33 percent of the purchases. As these three women riding on the Dyer Homestead in what is now the Pocasset cemetery discovered, long skirts hindered riding. Accordingly, some women started to wear bloomers.

The next leap forward in personal transportation was the automobile. Not only could a person live farther from his workplace, but he could explore a much wider area of the city, as evidenced in this c. 1920 photograph where a couple in a 1913 Ford convertible is seen winding down an unpaved Natick Road. Automobiles also provided economic benefits to Cranston. Besides a Maxwell factory, there were Ford and Franklin dealerships.

As more automobiles began to share the road with other vehicles including trolleys, accidents were inevitable. The 1912 Buick four-cylinder Model 43 received the lion's share of the damage in this Broad Street collision with the open-car trolley from the Rhodes-on-the-Pawtuxet Railroad line. (Courtesy of Henry Brown.)

The Hurricane of 1938 did serious damage to the Cranston coastline and the boats moored in the village of Pawtuxet. Countless homes were damaged, and hundreds of trees were knocked down throughout the city by the 120-miles-per-hour winds. Although 317 people died in Rhode Island, Cranston was the only coastal region with no loss of life.

An unusual type of transportation was seen in the skies over Cranston on May 6, 1937, as the German *Hindenburg* dirigible soared over the Cranston Stadium off Park Avenue. Tragically, the hydrogen-filled craft later burned that same day in Lakehurst, New Jersey, killing 36. Chester Browning, who lived nearby, took this photograph with his Kodak camera. (Courtesy of Virginia Browning.)

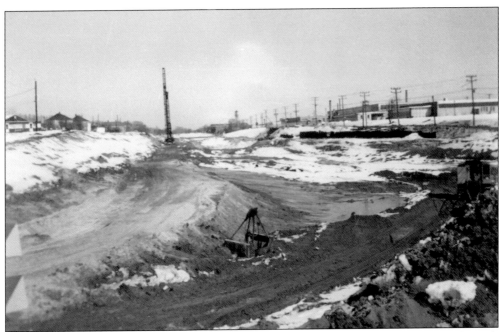

The need for better interstate transportation resulted in the building of Interstate 95 through Cranston. The construction of this six-lane highway and its cloverleaf interchange with Route 10 meant that many houses in the area, particularly in Friendly Community, had to be removed. This 1965 photograph was taken from Wellington Avenue. (Courtesy of Anne Crocker.)

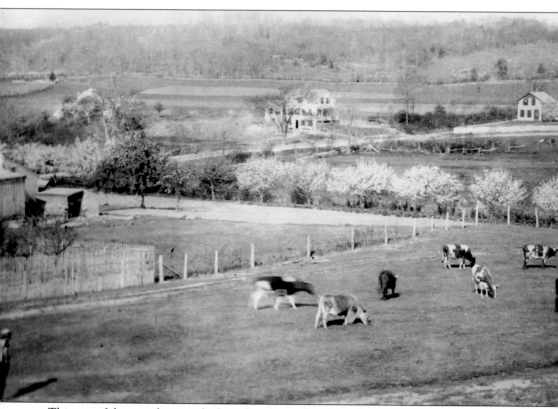

This peaceful pastoral scene of a dairy farm located in the valley surrounding Meshanticut Brook in Oak Lawn unfortunately no longer exists. Around 1970, much rural acreage and several historic buildings were sacrificed for the construction of Interstate 295 that winds its way through western Cranston. This new highway made it much more attractive for people to live in this section of Cranston and yet easily commute to work in other parts of the state. The result was even more residential development in the area and commuters often clogging the nearby narrow roads during the morning and afternoon rush hours.

# Seven

# RELIGION

Since many of the people who settled here were influenced by Roger Williams's belief in religious freedom, Cranston has long been home to a diverse group of churches and synagogues. Quakers, severely persecuted elsewhere in New England for their ideas on gender equality and direct communication with God, came to Rhode Island in large numbers in the late 1600s, and many settled in Cranston. At first, the Quakers worshipped in each other's homes, but in 1729, they built only the fourth Quaker meetinghouse in the country and the first church of any kind in the city.

The Baptists were another early religious group. In 1806, members of the Six Principal Baptist Church held a lottery to raise money for the Knightsville meetinghouse on Phenix Avenue. More religions later joined them in Cranston, including other national Protestant denominations such as Congregationalists, Episcopalians, and Lutherans.

With the influx of Irish immigrants in the mid-1800s, Father Quinn arrived to start the first Catholic congregation, and a small wooden church was built. St. Ann's officially became the first Catholic parish in 1863. When Italian immigrants subsequently arrived in Cranston in significant numbers, they built their own church, St. Mary's, next door. Two other parishes were established in the early 1900s to serve the Catholics in the eastern section of Cranston, and in the last half of the 20th century, three more Catholic churches were built farther west.

For a long time, Jewish people from Cranston worshipped in neighboring communities, but in the 1950s, two temples were established to serve their religious needs. Today, Cranston's religions are even more diverse. New churches, housing Christian Pentecostal, Greek Orthodox, and Coptic Orthodox congregations, have been built in recent years, primarily in the western section of the city where large tracts of land are still available.

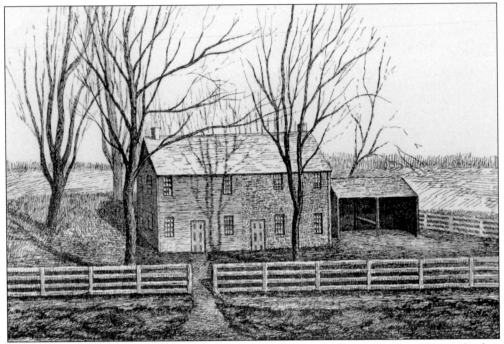

This Tallman engraving shows the Quaker meetinghouse, which was built in 1729 as the first church in what is now Cranston. George Fox had begun the Religious Society of Friends in England in the 1640s, but many members immigrated to New England to escape persecution. Elsewhere, they discovered that their beliefs angered the Puritan clergy, but in Rhode Island, they found religious freedom.

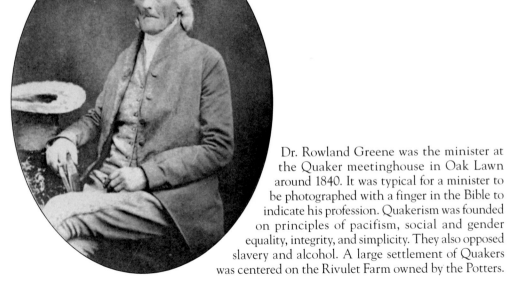

Dr. Rowland Greene was the minister at the Quaker meetinghouse in Oak Lawn around 1840. It was typical for a minister to be photographed with a finger in the Bible to indicate his profession. Quakerism was founded on principles of pacifism, social and gender equality, integrity, and simplicity. They also opposed slavery and alcohol. A large settlement of Quakers was centered on the Rivulet Farm owned by the Potters.

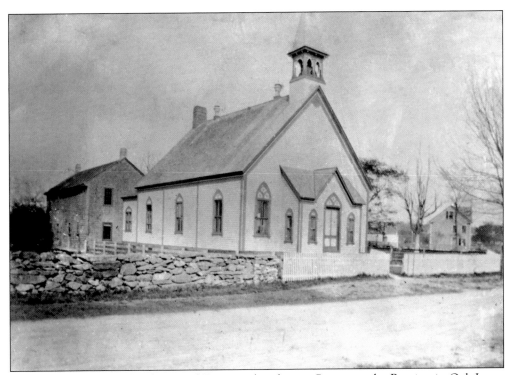

Although there were already several Baptists churches in Cranston, the Baptists in Oak Lawn wanted to form their own church. At first, they held their Sunday school meetings in what was the village school and is now the library. Because of declining membership, the Quakers sold their building in 1866 to the Baptists. By 1882, their Benevolent Society had raised enough money to build a new church on the same site, seen in the photograph above. The old Quaker meetinghouse was attached to the back of the new structure, as seen in the photograph below, and used as a dining hall for their social events. It was replaced with a more modern addition for the Sunday school and community hall.

Originally begun by Roby Wilbur in 1866 as a fundraiser for building the new church, the Baptists' May Day celebration consisted of a breakfast and then entertainment at night. The May Day breakfast is said to be the first in the country and remains very popular to this day. This c. 1903 photograph shows the May Day breakfast committee of church members. They are, from left to right, Chester Searle, Clarke Smith, Martha Searle, Ray Greene, Jennie Searle, Charles

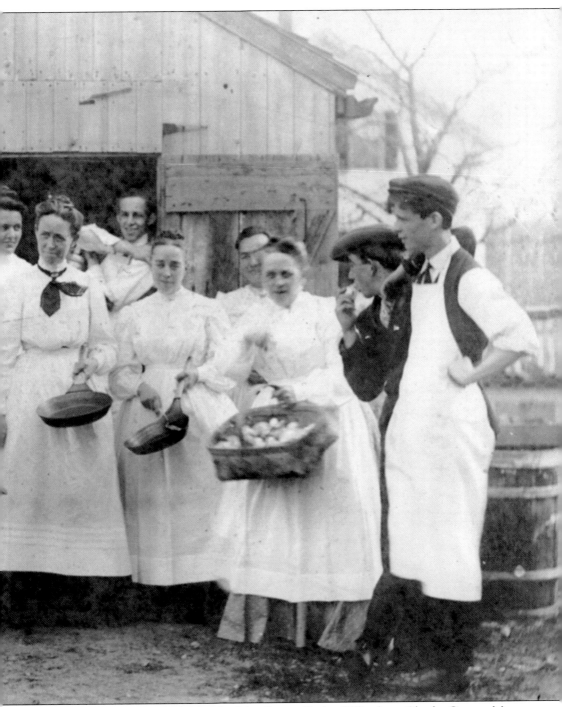

Tillinghast, Ben Sutherland (child), Mrs. John Sperry, Evelyn Tillinghast, Charles Greene, Mrs. William Kenerson, Mrs. Tyler Moone, Andrew Smith, and Raymond Sutcliffe. Andrew Smith seems to be annoying Mrs. Moone with some unauthorized sampling. One woman is partially obscured and is not identified. (Courtesy of Oak Lawn Baptist Church.)

In the early years, the May Day breakfast, along with all the church's other social events, would be held in this dining room, which was actually in the old Quaker meetinghouse that had been attached to the Oak Lawn Baptist Church. Since the breakfast attracted people from throughout Cranston, the women who served the meal worked quickly so that a constant wave of people could be fed.

Rev. Frederic Lent was the fourth pastor of the Oak Lawn Baptist Church, serving from 1898 to 1901. He was born in Nova Scotia and educated in the Newton Seminary. A November 17, 1898, newspaper article heralds his installation at the age of 26 and describes him as being "thoroughly imbued with the spirit of God." (Courtesy of Oak Lawn Baptist Church.)

In 1806, some 35 Knightsville men held a lottery to raise funds to build a Baptist meetinghouse. The sale of many $4 tickets eventually paid for the $2,500 building on Phenix Avenue. Town meetings were also held there regularly for almost 50 years. The Baptists disbanded around 1860, and other religious groups including Congregationalists later used the building. In 2010, the Knightsville Franklin Congregational Church sold the structure, one of Cranston's oldest buildings and in the National Register of Historic Places. The photograph above was taken in 1905, and the photograph below, taken in 1918, shows a prayer meeting with members sitting around a coal stove. (Below, photograph by Wilfred Stone [minister of the church from 1928 to 1957].)

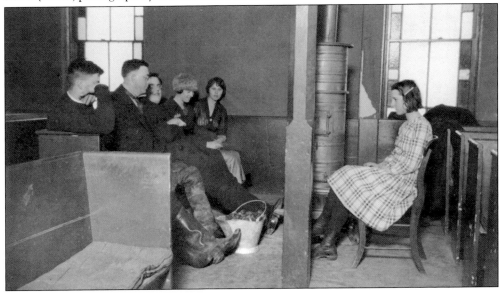

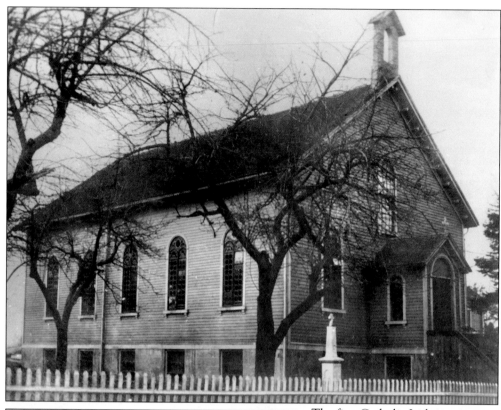

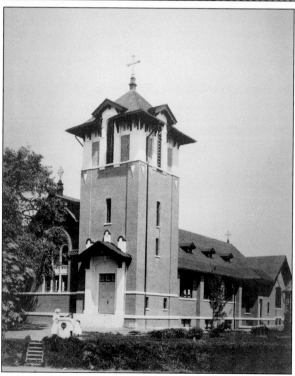

The first Catholic Irish immigrants, who came to work in the A&W Sprague Company textile mill on Cranston Street, had to attend church in Providence. But as their numbers increased, Father Quinn arrived in Cranston in 1853, and several years later, this small wooden church named St. Ann was built.

By 1909, the St. Ann congregation was celebrating Mass in the basement chapel of its new brick church. The upper portion with its rectangular bell tower was not finished until 1928. After Italians came to the area, but before they built their own church next door, St. Ann had Masses in both languages. Then in 2013, after incurring much debt, the church building was taken over by a Maronite Catholic community.

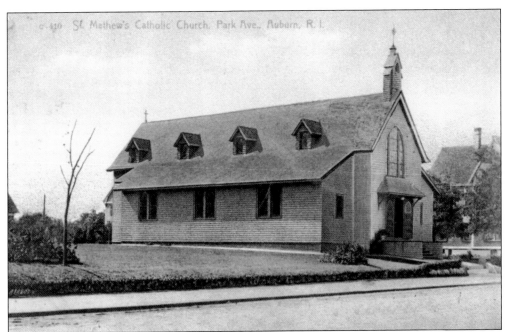

Churches of many denominations were built around the turn of the last century to meet the spiritual needs of the residents of the growing residential suburbs near Providence. Trinity Episcopal Church on Ocean Avenue was organized in 1883, the Edgewood Congregational Church on Broad Street started in 1891, and the Church of the Transfiguration, also on Broad Street, was built in 1893. The Catholic church named for St. Paul celebrated its first Mass in 1907, and St. Matthew's Church, seen in the photograph above, was consecrated in 1909. Over the years, the building has been changed, as seen in the photograph at right, but it still makes a commanding appearance on the corner of Park and Elmwood Avenues. (Right, courtesy of Don Rotteck.)

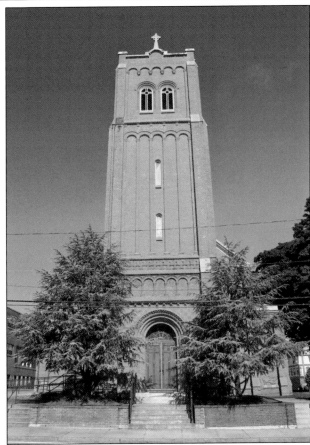

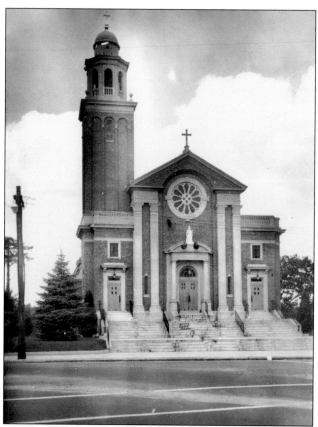

By 1921, when the number of Catholic immigrants from Italy had reached more than 3,500, they petitioned the diocese to form their own parish. In 1935, there was enough money raised to build the brick church, St. Mary's, with limestone detailing. Since many of the original parishioners came from Itri, they have celebrated that Italian town's traditional feast for over 100 years. The festivities include a special Mass, a parade, fireworks, and plenty of Italian food.

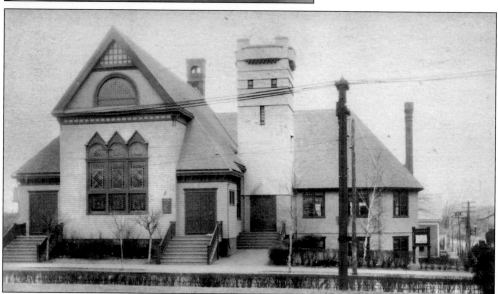

The Auburn Free Baptist Church was built around 1890 at 1275 Elmwood Avenue. The expansion of streetcar lines had caused this area to become a popular residential suburb for people working in Providence. This wooden building is currently the home of People's Baptist Church, a congregation of American Baptists.

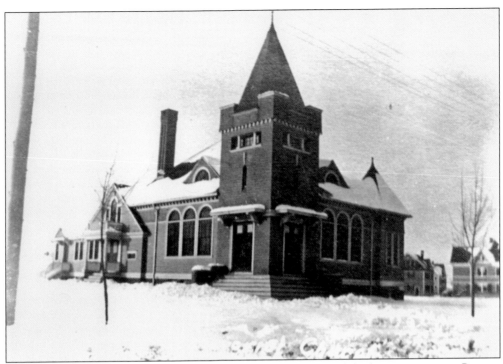

Another housing subdivision was established around the turn of the last century near Pontiac Avenue. The first Phillips Memorial Baptist Church, shown here in a 1902 photograph, was built on land donated by James Budlong, owner of one of the largest farms in the state. A newer church was erected in the 1940s and stands next to this one, which now houses a Sunday school and a nursery school.

In 1914, Hannah Clark began the Meshanticut Park Sunday School in her home on Cranston Street for 11 students, including her five children. Her efforts eventually led to the erection in 1924 of a church on the same street; the church's interior is shown in this photograph. The current Episcopalian church, St. David's on the Hill, was built in 1954 on Meshanticut Valley Parkway, and the parish house was erected seven years later.

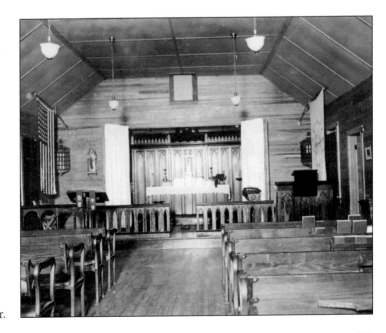

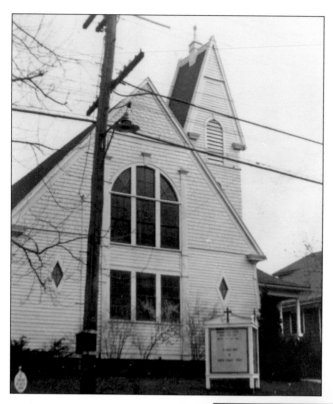

Another church on Cranston Street in Meshanticut Park is seen in this c. 1950 photograph. It started out around 1900 as a nonsectarian community church when a Congregational minister paid for the structure to be built and became its first pastor. But by 1909, with many of its members Baptist, it became an independent Baptist church. It was known for its symbolic Hand of God, seen in the photograph below, which pointed upward from the steeple. When the Meshanticut Baptist congregation moved to a new building on Oak Lawn Avenue in 1957, the Hand of God was placed in the vestibule. The older Cranston Street building now houses St. Patrick's Independent Catholic Church, and an Eastern Greek Orthodox church currently owns the newer building.

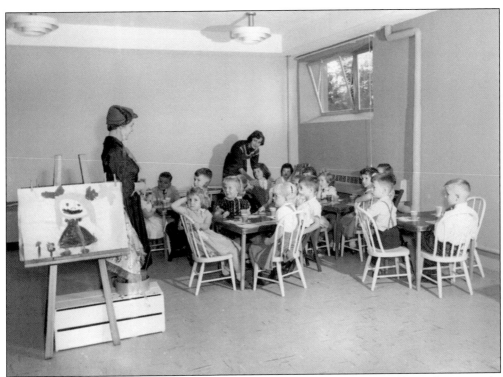

Sunday school was an important part of a church's mission. Alice Baxter, left, and her colleague taught the younger children at Oak Lawn Baptist Church in one of the basement education rooms, as shown in this 1956 photograph. Baxter was also a kindergarten teacher in the Cranston Public Schools and the longtime curator of the Cranston Historical Society. (Courtesy of Oak Lawn Baptist Church.)

Choirs were also an essential part of the religious service. In this 1950s photograph, the choir of St. David's Episcopal Church poses on the steps of the church building that was then on Cranston Street. Their long-serving minister Noah Gardner Vivian was appointed vicar in 1929 and then rector in 1950.

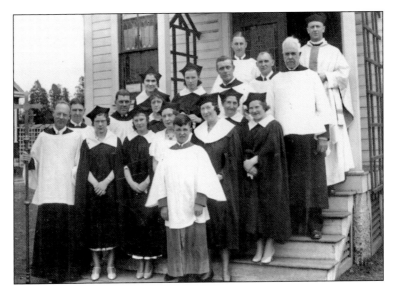

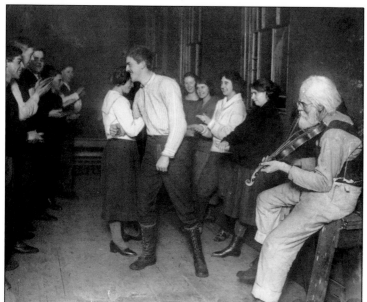

Churches offered a place for their members to socialize. These young members dance to the music of a fiddle at the Knightsville Congregational Church around 1915. While Earle Yeaw and his companion dance, the rest, including Charles Asahel Yeaw on the left, keep the tempo by clapping. (Photograph by Wilfred Stone.)

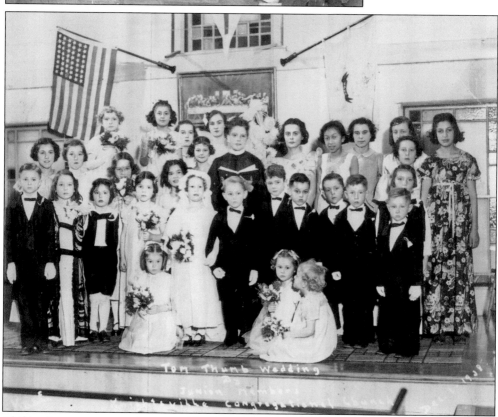

Children's programs were always good for drawing an audience to a church hall. The play titled *The Tom Thumb Wedding* was held at the Knightsville Congregational Church in December 1938. The rather flowery script reads, "Into this jolly estate these two lovely doves come now to be joined," but it also refers to marriage as "the iron bonds of padlock." (Courtesy of Elaine Miller.)

# *Eight*

# RECREATION

In the early days, most of Cranston residents' time was taken up by the household and farm chores needed to survive. For God-fearing and industrious people, church, school, grange, and fraternal order events took up some of their nonworking hours. But occasionally, there was time for simply having fun, and areas of the community began to cater to this need.

Starting in the 1840s, Edgewood sported Smith's Palace, which could be reached by a 50¢ steamer ride from Providence. It became a place for carnivals, clambakes, and other events. Eventually, Thomas Rhodes moved the clam pavilion to his own land and started Rhodes-on-the-Pawtuxet. This entertainment complex offered venues for dining, dancing, canoeing, and bowling. Edgewood was also the site of two yacht clubs, three canoe clubs, and Kerwin's Beach.

Narragansett Trotting Park, owned by Amasa Sprague II, opened in 1867 for horse racing. Under different ownership, it later switched to automobile racing and was the first oval paved track in the country in 1896.

In the late 1800s, Emery Park was established as a picnic area on Blackamore Pond. It boasted of the "miraculous" Ponce De Leon Spring with luminous water. Later, a casino and a dining hall were built, and when electric lights were added, nighttime dancing and athletic events took place.

Golf courses and country clubs became popular in the early 1900s, and two remain today. For those not wealthy enough to join a country club or a yacht club, there were less costly leisure activities found in theaters, bowling alleys, and parks.

Improved transportation made it easy to go outside the city for recreation. First, streetcars provided access to Rocky Point and South County beaches. Later, automobiles and then planes allowed people to find amusements outside of Cranston.

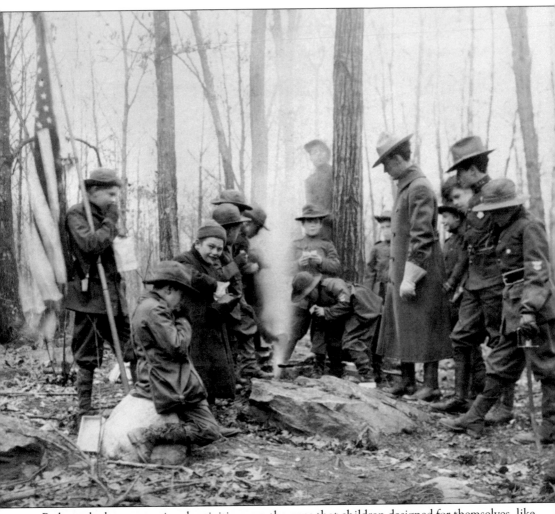

Perhaps the best recreational activities were the ones that children designed for themselves, like playing sandlot baseball and swimming in a local pond in the summer or skating and sledding on any available frozen surface in the winter. In those simpler times, parents felt comfortable letting their children play in the neighborhood without adult supervision. But sometimes, young people's recreational activities were more organized. The Boy Scouts offered a way for boys and teenagers to learn useful skills and develop strong characters under the guidance of adult leaders. For many years, the Boy Scouts have had a campground on Scituate Avenue in western Cranston called the Champlin Reservation. The camping experience for the boys in this photograph cultivated self-reliance and taught survival skills.

Men, such as the fishermen in this 1921 photograph, also enjoyed outdoor activities. In early Cranston, fishing would have been more of a food-getting necessity than a sport, and for some residents of Pawtuxet, fishing became a commercial enterprise. But for many, fishing was a relaxing pastime that could also result in dinner. (Photograph by Wilfred Stone.)

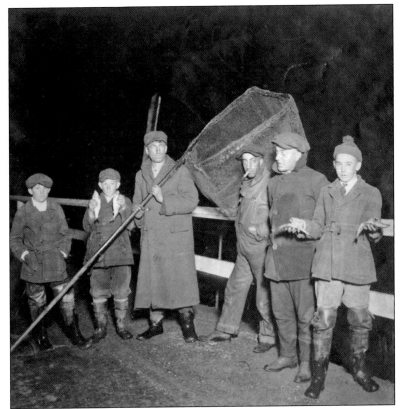

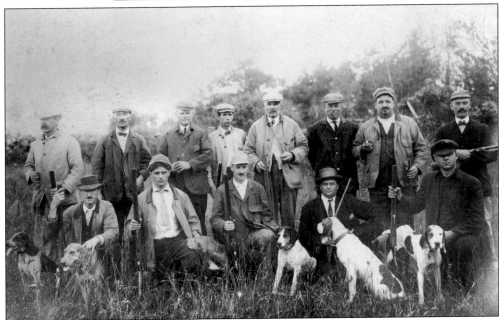

Another form of recreation that might result in getting food for the table was hunting. This club, located in Arlington, appealed to men who enjoyed hunting with their dogs and rifles. The man in the lower right corner is Seneca Stone; he was the dog officer for the city in 1918.

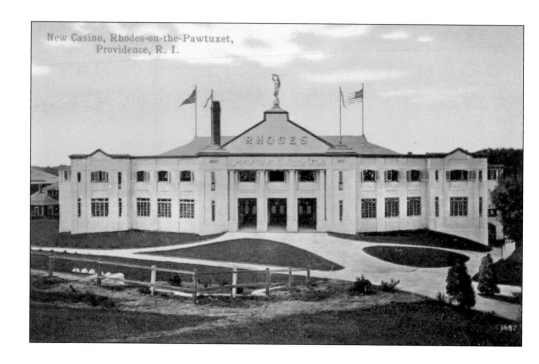

For a variety of recreational activities in a beautiful setting, nothing beat Rhodes-on-the-Pawtuxet, located off Broad Street. Started by Thomas Rhodes in the 1890s as a clambake restaurant and dance hall, the first casino burned down in 1915. Within a few months, the Rhodes brothers built another casino on the same site, as seen in the above photograph. Note the postcard incorrectly states that the casino is in Providence, Rhode Island. Part of the attraction was that the property was on the Pawtuxet River, making its boathouse a convenient embarkation point for canoe and boat rides. (Above, courtesy of Donald Carpenter.)

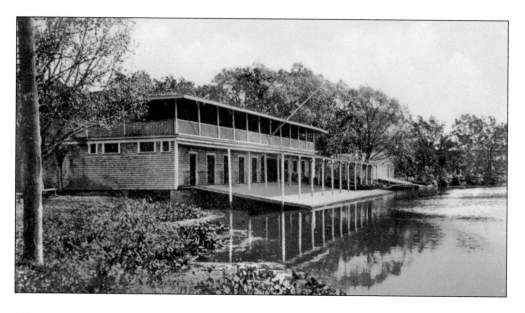

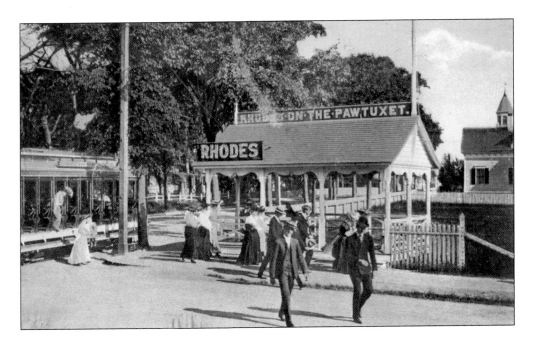

Seen above are people disembarking from a streetcar on Broad Street. Many of those pictured were most likely going to the Rhodes-on-the-Pawtuxet Dance Pavilion. The popularity of the Rhodes-on-the-Pawtuxet Dance Pavilion continued well into the 1940s. Pictured below is the interior of the pavilion.

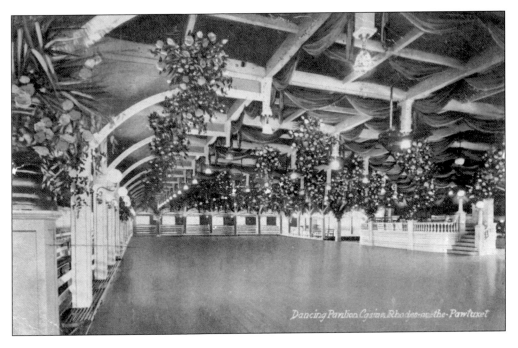

*Dancing Pavilion Casino Rhodes-on-the-Pawtuxet*

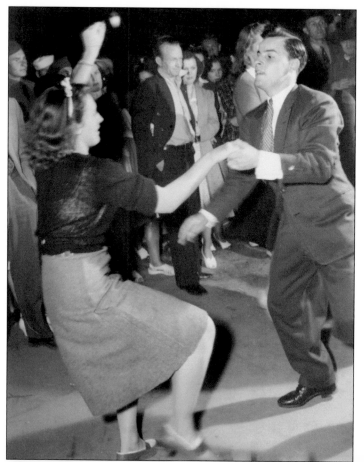

Over time, the style of dance changed greatly. The stately waltzes from the turn of the century gave way to more lively dances like the Lindy Hop and swing. Nationally known big bands led by conductors such as Glenn Miller and Guy Lombardo came to the pavilion in Cranston and were enjoyed by hundreds each weekend, including servicemen on leave and their girlfriends. In more recent years, the ballroom has been used for high school proms and as a gathering place for various organizations and their events. (Both, courtesy of Henry Brown.)

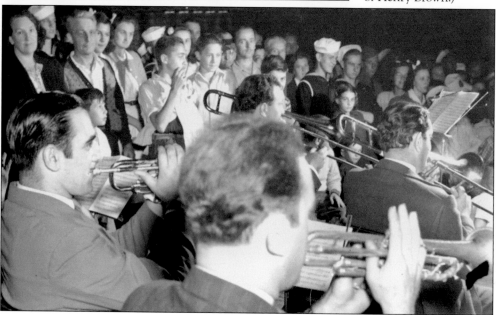

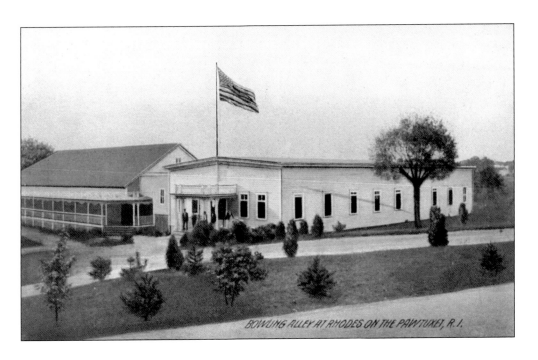

When the Rhodes-on-the-Pawtuxet was rebuilt in 1915, the new casino building included a large bowling alley, as depicted in the 1918 postcard above. Since bowling was becoming a popular pastime, including among families with children, this increased the number of people who would enjoy recreational activities at the Rhodes family establishment. It also attracted people during the day and on those evenings that the dances were not held. The postcard below shows the interior of the bowling alley. (Above, courtesy of Henry Brown.)

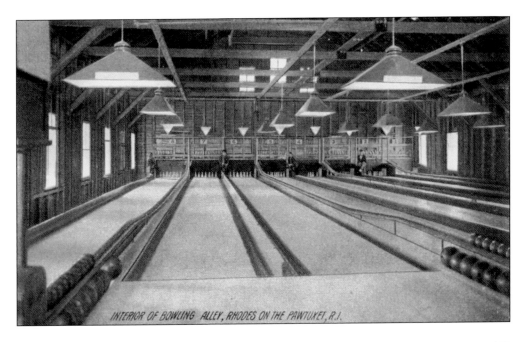

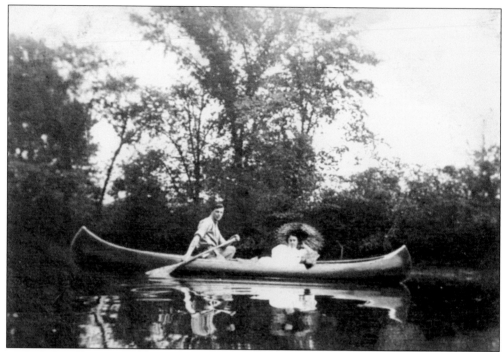

Canoeing was a popular sport around 1900, and it was said that more canoes plied the Pawtuxet River than any other river of its size. Depending on one's choice of companions, canoeing could be an athletic competition or a romantic interlude. Pictured around 1910 is George Smith courting Olive Conyers.

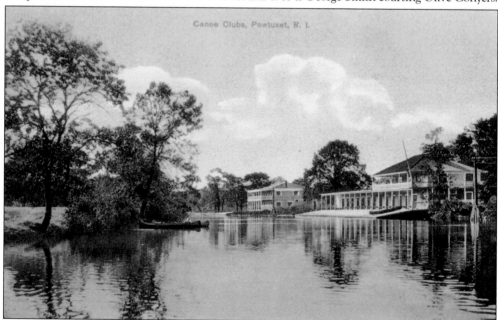

Several canoe clubs erected buildings on the Pawtuxet River, including the Saskatchewan Canoe Club, the Rhodes Canoe Club, and the Swastika Canoe Club. As with many wooden buildings, fire was always a threat. The boathouses for all three canoe clubs burned to the ground between 1907 and 1915.

114

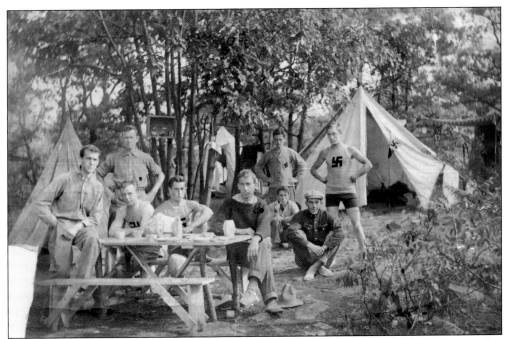

The name for the Swastika Canoe Club is from the Sanskrit word *svastika*, often interpreted as "to be good." Long after the men in this photograph enjoyed a camping trip with their fellow members, the name of their club and its symbol developed a sinister connotation when associated with Nazism in the 1930s. (Courtesy of Henry Brown.)

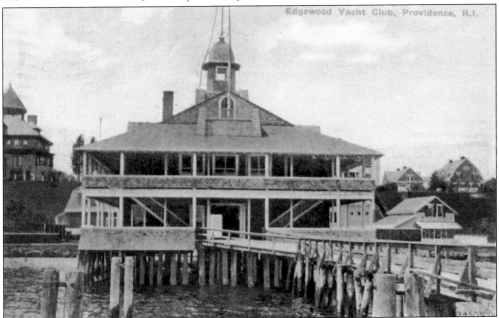

Cranston has been the site of two yacht clubs, although this 1911 postcard misidentifies the location of the Edgewood Yacht Club. The building was erected in 1885 and attracted the prosperous families from the area, many of whom were wealthy Providence business owners. The club has continued, although the clubhouse burned in 2011. (Courtesy of Henry Brown.)

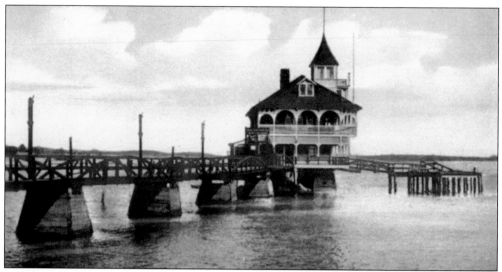

Another sailing club was organized in 1875. Although it was in Pawtuxet, most of the members came from Providence, and it was called the Providence Boat Club. In 1885, it was renamed as the Rhode Island Yacht Club. Over the years, three clubhouses have been built, since the first two were destroyed by hurricanes in 1938 and 1954.

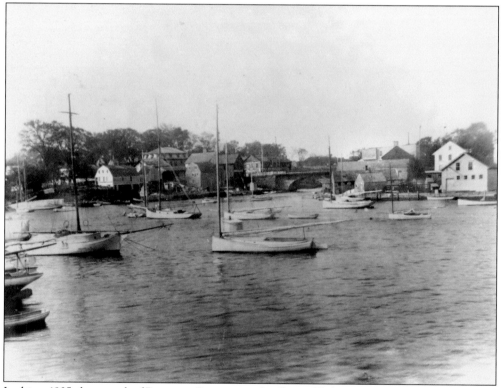

In this c. 1905 photograph of Pawtuxet Cove, moored sailboats fill the area near the Pawtuxet Bridge. The cove, framed by the Pawtuxet Village on one side and Pawtuxet Neck on the other, remains a popular place for boating since it connects to Narraganasett Bay. Today, it is the site of a busy marina and businesses where kayaks and canoes can be rented. (Courtesy of Henry Brown.)

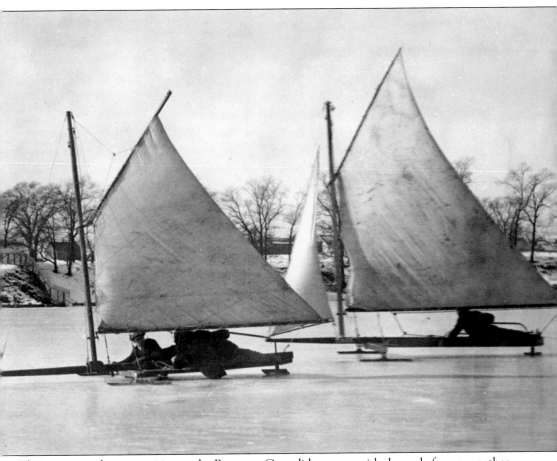

The recreational opportunities on the Pawtuxet Cove did not stop with the end of warm weather. Gliding along the cove's frozen surface in a specially designed iceboat with sails was a favorite winter sport. Runners, or skates, were attached to a simple platform that was outfitted with a mast and sail. The earliest iceboats were water sailboats with basic modifications, including a wooden plank fastened crosswise at the bow with a fixed runner at each end and a steering runner attached to the bottom of the rudder at the stern. (Photograph by Wilfred Stone.)

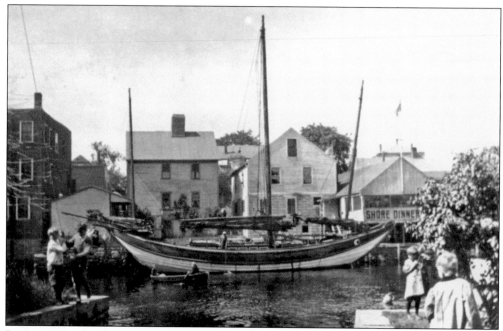

Pawtuxet Cove had many attractions for people seeking a pleasant time near the water. One did not have to own a yacht to enjoy looking at the ones that were tied up nearby. A shore dinner at the nearby Slocum Bake House was affordable for most residents of the area. (Courtesy of Henry Brown.)

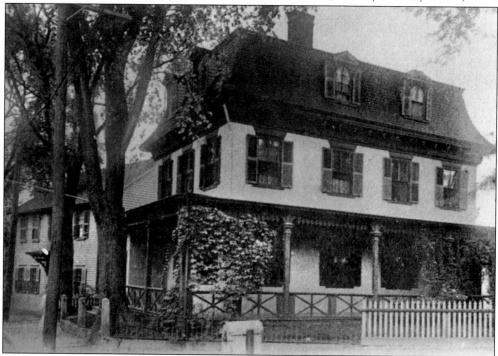

With so much to do in Pawtuxet because of its shoreline location, it was understandable that tourists were attracted to the area. Some just came by trolley for day trips, but others wanted to stay overnight. The Smith Hotel was one of the facilities that were built to accommodate these tourists.

In the mid-1800s, the Washington Trotting Park was constructed in Providence near the Cranston border. When the park started attracting a large following, John Chace built a small hotel in Cranston on Pawtuxet Road (now known as Broad Street) near where Bayview Avenue is today. The Cranston Hotel, as its sign announced, accommodated the Trotting Park's patrons and horse trainers.

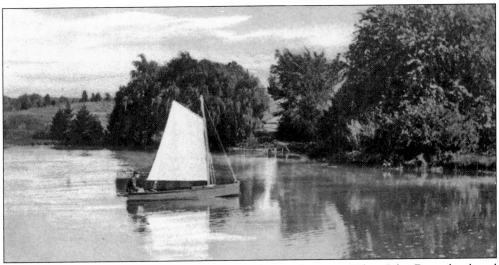

People did not need to live by the ocean to have fun on the water. When John Dean developed the suburb of Meshanticut Park in 1894, he dammed the Meshanticut Brook, creating this pond surrounded by a park. Dean gave land for the Wayland railroad station and laid out Cranston's first golf course near the plat. Such amenities attracted buyers to the development.

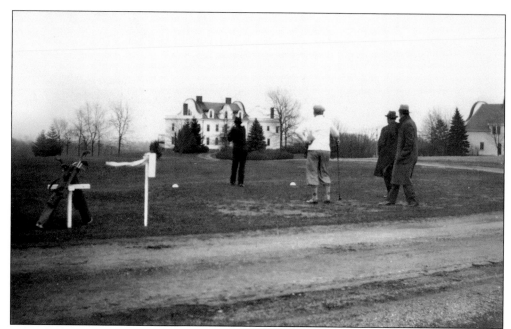

Hattie and Jonathan Comstock opened the Cranston Golf Club in 1929 as the state's largest nine-hole golf club. In the photograph above, a group of men enjoys the fairway near the Comstocks' distinctive house and barn. John Burton's home, built in 1743 and seen in the photograph below, served as the clubhouse and contained the Homestead Tearoom. In 1931, the facility expanded to 18 holes and was renamed Comstock Park. In 1942, the Comstocks plowed under the fairways and gave the land to tenant farmers in order to provide crops for the war effort. When World War II was over, the area became a residential subdivision. (Above, courtesy of the Worthington family.)

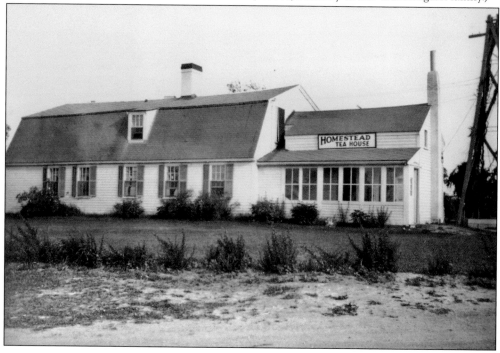

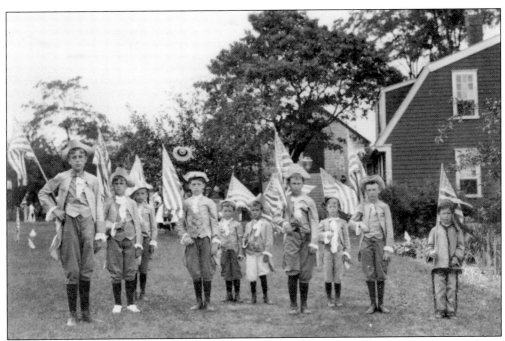

Who does not love a parade? It would appear that one popular way for Cranston to celebrate the birth of this nation was dressing up in costumes and participating in a parade. Oak Lawn's parade was famous for many years. In the 1904 photograph above, young members of the Oak Lawn Baptist Church are dressed in Revolutionary era–style clothing and ready to march down a street in their village. Seventeen years later, the Ladies Auxiliary won third prize in the Fourth of July parade of 1921 just by wearing matching hats and riding in a horse-drawn wagon. (Both, courtesy of Oak Lawn Baptist Church.)

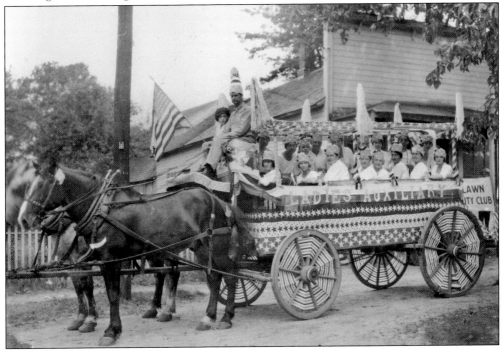

Originally owned by Amasa Sprague, the Narragansett Trotting Park featured horse racing. This photograph shows William Comstock and one of the racers. Cornelius Vanderbilt and J.P. Morgan attended the park's 1867 opening. After 1873, it was owned by several organizations, including the Rhode Island State Fair Association. It became the site of the country's first automobile race on an oval track in 1896 and the first race on asphalt in 1915.

The Narragansett Park was also remembered for being the site of the pageant that commemorated Cranston's 150th anniversary of its incorporation as a town in 1754. In this 1904 photograph, General Tanner and other dignitaries on horseback have the honor of leading the parade, which was a highlight of the festivities.

Many local organizations participated in the 150th anniversary pageant. The Gaspee Boys had a float that honored Rhode Island's first strike for freedom by burning the HMS *Gaspee* in 1772, before the American Revolution. This area of the park is now the site of the Cranston Stadium and Stadium School.

For some people, exploring history is an engaging pastime. In 1949, a group of Cranston residents incorporated the Cranston Historical Society. This c. 1950 photograph shows some of the early members meeting in the Knightsville Congregational Church. In 1959, the organization purchased the Joy Homestead, and the meetings were held there.

The Cranston Historical Society's first president was John Stuart. The organization has always been run by volunteers willing to donate their time to preserve Cranston's history. In perhaps its most important project, the Cranston Historical Society succeeded in saving from demolition the Governor Sprague Mansion that then became its headquarters in 1967.

As part of its community outreach, the Cranston Historical Society holds an annual Christmas Open House. In this photograph taken at the Sprague Mansion in 1968, Alice Baxter and two young friends model costumes from different time periods. The boy is wearing a mid-1800s outfit once owned by Amasa Sprague. (Courtesy of Tom Worthington.)

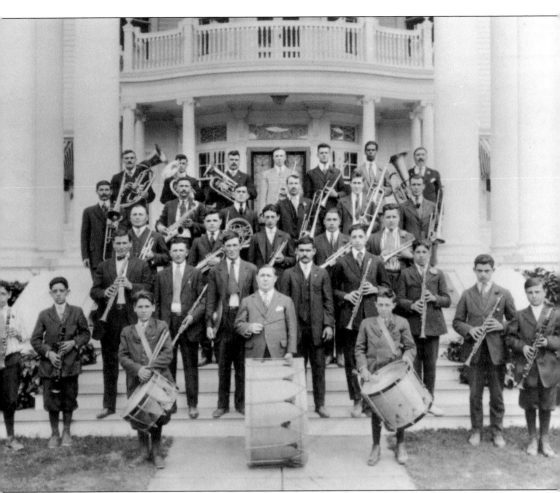

For those who enjoyed making music with a group of like-minded enthusiasts, a band was a popular recreational activity. This c. 1920 photograph shows the Knightsville Band, playing in front of John Dean's mansion, which was located on Sockanosset Hill off Oak Lawn Avenue. Unfortunately, some of the full names have been lost. Pictured are, from left to right, (first row) ? Delbonis, Pat DeLuca, Pete Capirchio, ? Marsella, Flori Soscia, unidentified, and Mike Spirto; (second row) ? Agnoli, ? Bambino, ? Devona, ? Ianone, Andrew Squizzero, and Tony Sepe; (third row) ? Sinapi, ? Picano, Joe DiBiase, ? Soscia, and Joe Ruggieri; (fourth row) ? Biasi, ? Aquili, Tom DiAmbra, ? Palumbo, ? Capatosta, and ? Ruggieri; (fifth row) Salvatori Capircho, Pat Manzi, Joseph Tamburrio, Pat Saccocia, and three unidentified band members.

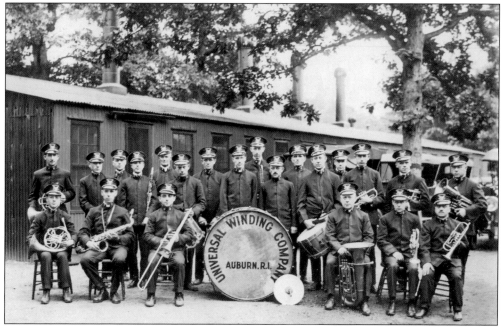

Sometimes, recreation blended with work as companies offered their employees the opportunity to participate in sports teams and bands. Since the Universal Winding Company on Elmwood Avenue made war materials during World War I—including parachutes, hand grenades, and machine guns—its workers needed a pleasant respite from their jobs.

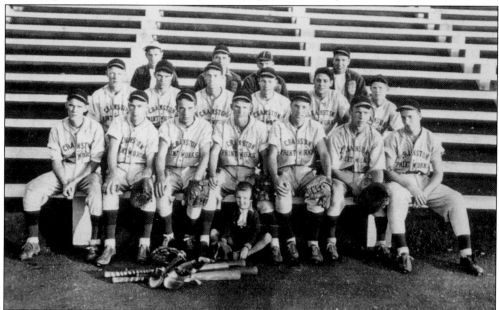

In this 1954 photograph, the Cranston Print Works baseball team is shown. Members are, from left to right, (first row) Hollie Salisbury, Charles Mahoney, Ernest Deshene, Dick Vieweg, Buddy McElroy, George Noonan, and Buddy Malone; (second row) James Bryan, Ellie Cole, Bill Harvey, Mel Zarisian, and Don Jones; (third row) Herb Nicholas, Bill Horridge, Rodney Stubbs, and George Hopkins.

Schools also provided students with the opportunity to play team sports. This early-20th-century Cranston High School baseball team includes Earl Potter, Will Robbins, Carl Weitz, Ralph Griffith, Ben Johnson, Roger Withey, Leslie Bushnell, and James Tabb as well as a four-legged friend. One teammate is unidentified.

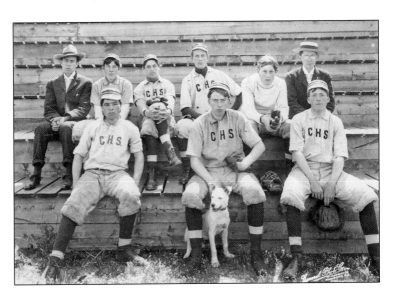

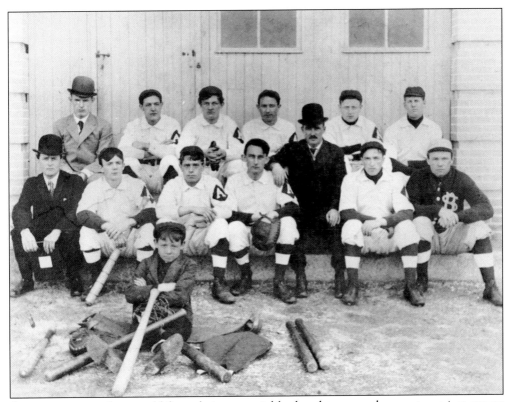

Sometimes, sports fans would form their own neighborhood teams and compete against groups from other communities. This baseball team from Auburn includes Jim Ashworth as the mascot. The players are Jack Curry, Bert Mason, Tom Boyle, Jack McGuigan, Cris Jennings, Bill Reynolds, Jack Boyle, Frank Fisher Case, and Prescott Matterson. Other individuals are not identified.

# DISCOVER THOUSANDS OF LOCAL HISTORY BOOKS FEATURING MILLIONS OF VINTAGE IMAGES

Arcadia Publishing, the leading local history publisher in the United States, is committed to making history accessible and meaningful through publishing books that celebrate and preserve the heritage of America's people and places.

## Find more books like this at
## www.arcadiapublishing.com

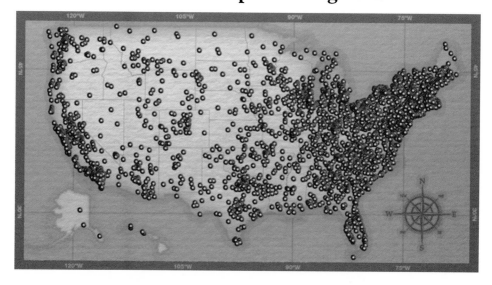

Search for your hometown history, your old stomping grounds, and even your favorite sports team.

Consistent with our mission to preserve history on a local level, this book was printed in South Carolina on American-made paper and manufactured entirely in the United States. Products carrying the accredited Forest Stewardship Council (FSC) label are printed on 100 percent FSC-certified paper.

**MADE IN THE**